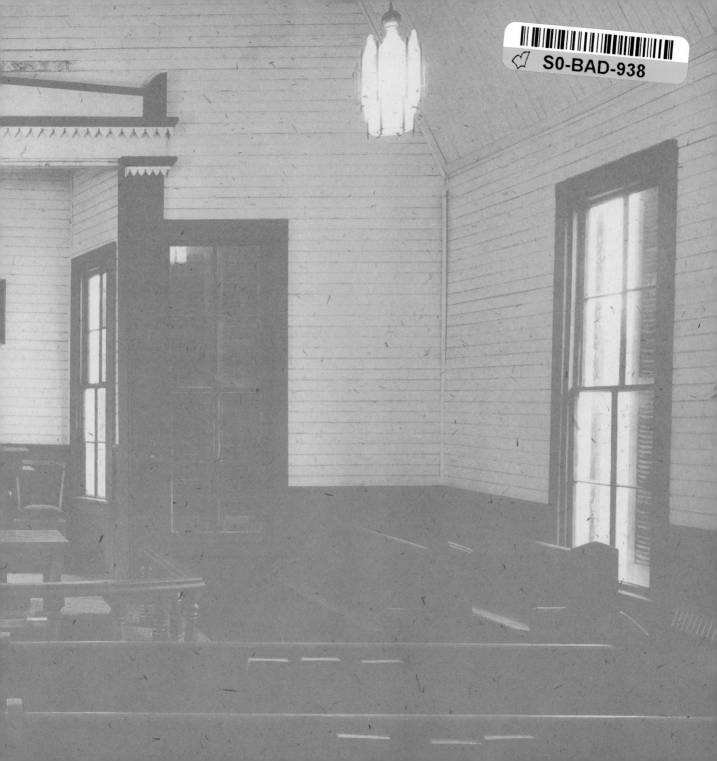

Wooden Churches

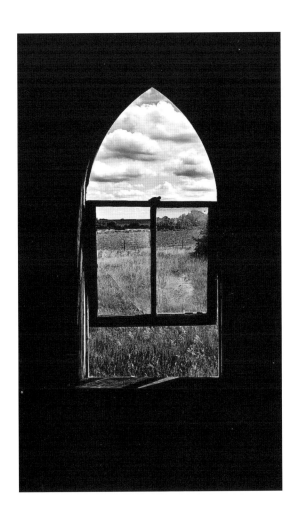

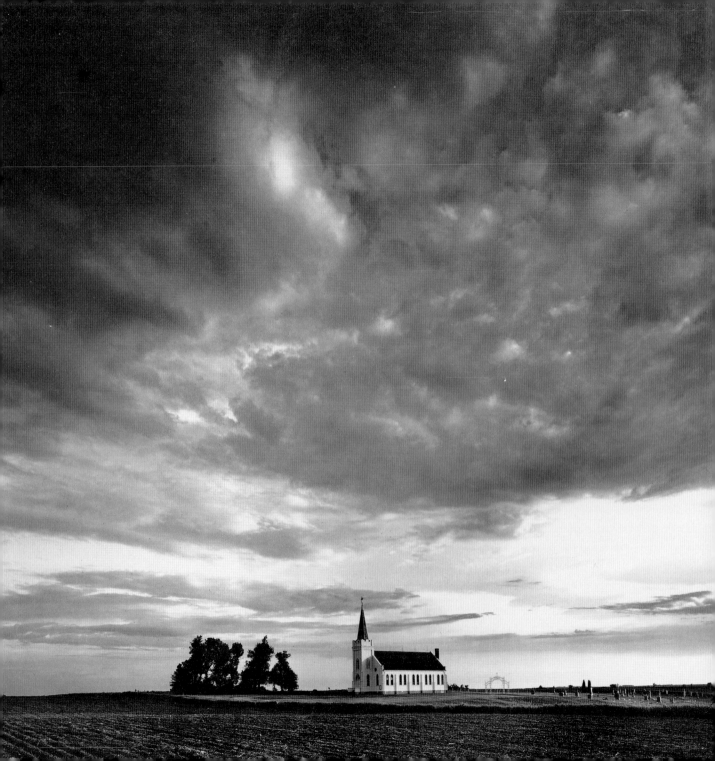

Wooden Churches

A CELEBRATION

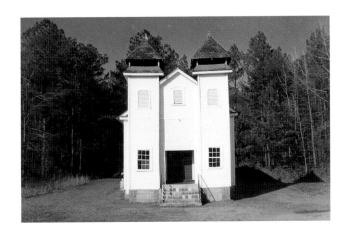

with an Introduction by

RICK BRAGG

ALGONQUIN BOOKS OF CHAPEL HILL

1999

Photographs on opening pages, in order:
Webster County, Nebraska; Colfax County, Nebraska;
Sprott, Alabama.

Published by
ALGONQUIN BOOKS OF CHAPEL HILL
Post Office Box 2225
Chapel Hill, North Carolina 27515–2225

a division of
Workman Publishing
708 Broadway
New York, New York 10003

For permission to reprint the quotes and photographs in this volume,
grateful acknowledgment is made to the holders of copyright, publishers,
or representatives named on pages 119–121, which constitute an
extension of the copyright page.

Library of Congress Cataloging-in-Publication Data
Wooden Churches: a Celebration / with an introduction by Rick Bragg.
 p. cm.
 ISBN 1-56512-233-X
 1. Church architecture—United States Pictorial works. 2. Wooden
 churches—United States Pictorial works. 3. United States—Religious
 life and customs. I. Bragg, Rick.
 NA5205.W66 1999
 726.5'0973—dc21 99-27930
 CIP

10 9 8 7 6 5 4 3 2 1
First Edition

North Georgia

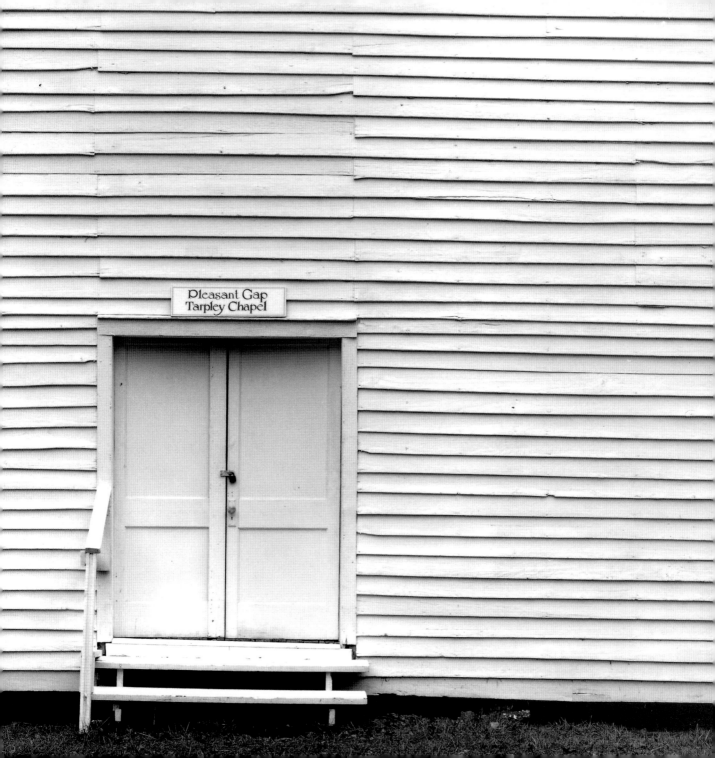

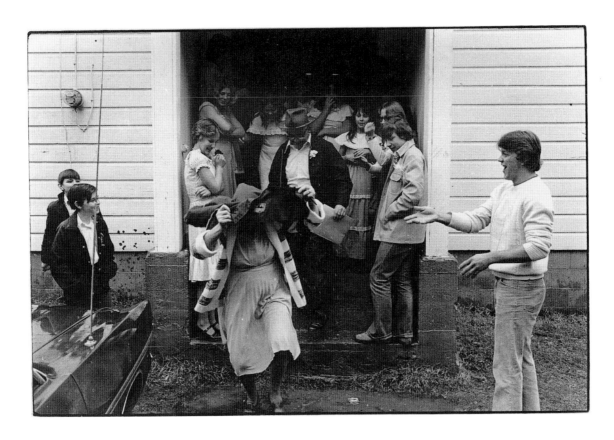

Madison County, North Carolina

Introduction

RICK BRAGG

*I*F I AM EVER GOING TO ROB A BANK IN A SMALL TOWN, I WILL ROB IT AT ELEVEN O'CLOCK ON A SUNDAY MORNING, WHEN THE ONLY LIVING THINGS ON THE STREETS ARE DRAGONFLIES, STRAY DOGS, AND BACKSLIDERS.

I grew up in Alabama, and to say that people there believe in God is like saying that they believe walking in a thunderstorm will get them wet. But even if I have never been to the town I rob, I will choose a Sunday and I know how it will be.

It will be quiet as the deep inside of nothing, and the sun will beat down on the town closed up tight, still, and silent, as if some Yankee tourist on the way to Florida snapped an Instamatic of its quaintness as they drove south, and stuck the whole thing on their refrigerator with Scotch tape.

Any other time, even if it is the smallest and sleepiest of towns, it would be crowded with people just living. Cars, mostly American cars with baby moon hubcaps and two-tone Ford pickups with the spare tire in the back, will crawl down Main Street, and mommas will hold their babies' hands so tight that their knuckles turn bone white, because everyone knows that a child—especially boy children,

who do not have good sense—will run out in front of cars, if given a chance. People will say "hey," even if they do not like you, and maybe there will be that thumping sound in the distance from the engine that drives the cotton gin, or the far-distant rumble of coal trucks on the highway. The air will be alive. It will smell like passing chicken trucks and frying pork chops, and when the door to the drugstore eases open, it will smell for a little while like soap.

But not on a Sunday, eleven o'clock. In a small town, all it takes is one loud deacon to stir things up. On a Sunday you can throw a rock all the way down Main Street and not once have to worry about the sound of glass breaking or babies crying. On a Sunday the only person keeping an eye on things will be an old drunk weaving his way from nowhere special to no place in particular, and he will only be watching his feet. A really drunk man has to watch his feet.

The bank will just sit there waiting to be robbed, without your even having to hurry very much, because on a Sunday the whole town belongs to the Lord, and on a Sunday the Lord has a place for you to be.

It may be as big as a mountain or as small as a double-wide trailer, but it will most likely be white, and it will be pounded together with tenpenny nails through pine, and even if age has made the whole thing frail and ragged as an old beggar and the paint is peeling like dead skin, it will have a cross on it somewhere, and then there can be no doubt, no discussion, that this is and always will be the House of the Living God.

Say Amen, somebody.

It will be square, because God doesn't need a lot of twists and turns and funny angles in His house. Only city people think a church has to be an architectural wonder to be worthy. Country people know it just has to be white and solid, and if

over time it happens to lean a little bit from age, then that's only because the Lord wanted it to lean that way.

The pews may or may not have any padding in them, but if the preacher knows that this is His time and not the preacher's—they sometimes forget that—then it doesn't matter how much padding the pews have. The preacher will preach until you are numb from the waist down, but, then, you don't need legs if you have wings.

It will have some stained glass, even if it is just a piece as big as a dinner plate, and a brown wooden altar with a fake gold cross laminated into it, and an organ that has been played by the same woman in the same cat glasses since Lester Maddox was governor, and the same hymnals with the same hymns, and sometimes an old woman will flip to a page with "I'll Fly Away" on it, think about how fine her late husband used to sing it, and start to cry.

It will have pictures, bought by mail from the Southern Baptist Convention or the National Baptist Convention, USA, or some other such, that show Jesus at the Last Supper, and it will be so beautiful and so peaceful that you will almost forget what happened next, and the children will stand in front of it and argue which one Judas is. There will be a picture of Christ on the Cross, and that will be beautiful, too, in its tragedy, and the expression on Christ's face, with the nails pounded into his hands and feet, will be so kind and forgiving and, well, you'll know you can never be that way, that good, no matter what the preacher says. In the little room where the youngest children have their Sunday school, there will be a picture of lions lying down with lambs. It will be there. See if it ain't.

But mostly the church will have people, and they may be white and they may be black or they may be worshiping in Spanish or Korean, but they will be there, because if there is no faith, there is just everything else, just living, and living can be so damn hard. On Monday they may have to visit their momma in the county home, or go back to work at the chicken plant, or lace up their white shoes and flip

hamburgers on the interstate, or maybe just stare into a mirror and accept the fact that so much of their life is gone and there is just a sliver left, and then what?

On Sunday there is the promise of something else, a promise that seems to sound so much truer in wooden churches, of a reward for all that human suffering. Even for the people who are not buying all that milk-and-honey business, there is a promise of peace, and peace is enough.

But nobody rides that glory bus for free, and for an hour or two or more the preacher is going to make plain what it is you have to do to get on the bus.

I know how he will be. He will be in his fifties or sixties because no one really likes an upstart, and he will sweat through his suit, and he will burn with the mighty anger of the Lord, because no matter how much the preacher tells us that He is a just and kind God, there is always that hell business to contend with. He will maybe take off his watch and place it on the podium in front of him, which, as the old joke goes, don't mean a thing. He may be black or white, but he will, unless it is a rich folks' church, "get happy" at some point. Getting happy does not mean he will be pleased, just that his feet are that way, and he will stomp—in thick-soled wing tips or patent leather—and hop a little and say things like, "Say Amen, somebody," and he will start to speak in half sentences when he catches his breath, and if you are a child it will all be just a little bit frightening.

He will scare the hell out of almost everybody before he is done, even if he is a gentle preacher, because when you get right down to it, it's hell that is frightening, not a man sweating through his suit, and when he makes the call to the altar someone will surely come. It may be that long holdout, the man who was torn between loose women and religion, or the woman who always had a little gin mixing with Jesus on her lips, or it may be a rush. He may preach so good that he opens a big ol' wide place between heaven and earth, and then people will rush to the altar so fast and hard that you will wonder, being a child and all, why the whole church

doesn't just tip over from all the misplaced weight, like a lifeboat that too many people are trying to pull themselves into from the cold, black waters of life.

I think the right time to rob that bank will be right then, just as the first chorus of "Just As I Am" is coming to a close, as the minister reaches out and places his hands on the heads of those who have just been saved. The entire attention of a community will be riveted on those people, on those souls, and nothing will really matter much for a while, not on this earth.

Of course, I don't plan to rob any banks. It's just something I used to think about when I was a boy, which makes about as much sense as anything boys do, like carrying live toads in their pockets and pulling little girls' hair to show their affection.

For as long as I can remember, life has been punctuated by wooden churches. It doesn't matter if you believe in the religion. If you grow up in the country, in small towns or big ones, they stand on almost every corner, on every tenth-mile of pine barrens and pastureland, to remind you that there are people who do believe.

When you get right down to it, there is just something good about wooden churches. You drive by them and a feeling of peace brushes fleetingly across your conscience, the way a mother's cool hands brush your forehead when you are sick or scared or mad. And the older I get, the more I am all those things. I have driven across land so flat that I felt I would surely just drive off the edge if I kept going, and seen a simple white church off in the distance, and thought that maybe the landscape is not so dull, so bleak, after all. Just the sight of it, and the world is round again, and there is the gravity of other people's faith to keep me safe and tight to this earth.

I remember once being lost in Mississippi, and stopping to ask a man in a churchyard exactly where I was. He told me I was in Mississippi, sure nuff, and I laughed out loud. Another time I was driving too fast through Arkansas, the speedometer twitching toward ninety, and a white church appeared around a bend

in the road, and I immediately slowed out of respect. But I was still doing seventy as the rental car plowed on through that little community, and the church people in the parking lot looked hard at me, and I was ashamed. Funny how that can be.

I guess it's just that feeling, something small-mindedness and prejudice cannot destroy. I know they handle snakes in churches in Sand Mountain, Alabama, and that in the mountains of the Carolinas and Kentucky they fling themselves to the floor and roll around. I know people who shudder or laugh at all that. But what you have mostly is good people sitting on hard benches, fanning themselves with fans donated by the local funeral home and getting right with God.

I used to think there was something magic about them, those people, and I believed that almost all of my life, until the spring of 1994. That was when a tornado ripped through a little church in northeastern Alabama the Sunday before Easter, killing old people, killing children. There was just something bad wrong about that. How could people die in His house? How could He let that happen? And then I heard a preacher say that faith has nothing to reason. Faith is what you have when there is no reason.

Faith is what you have, he explained, *when everything else is in pieces on the ground.*

A gas station owner explained it to me a little better not long after. "The ones he took were the lucky ones," he said. "He has them now." God took them while they were singing praise in His name, while they were on their knees in His name. He took them while they were in church, so how can there be any doubt that they will go to Heaven?

It's the rest of us, the gas station owner said, who should weep. We will die outside His house, and we will have to wait at the gate like everybody else, in doubt. They don't make them out of wood much these days, and the small towns are busy even on Sundays, with convenience stores and fast-food joints and other things that

do not respect the Sabbath, and on the interstate, traffic moves too fast to really get a good look at a church, wooden or otherwise.

Towns seldom shut down anymore, which is just as well. I'm too old and gimpy to rob anything more forbidding than my sock drawer. I would get caught for sure.

I don't see as many of the old-style churches now. In Georgia the kudzu has claimed a lot of them, snaking up the steeple, creeping in through the windows, crawling across floors that used to shake with the joy and sometimes the anger of God's word. And when I see things like that I am always a little sad, because they are a part of my youth and I guess even my soul, and I want them to stand forever.

Now and then I will drive by a little community and see the bricklayers out sweating in the sun, tapping into place the red rectangles of baked clay that will outlast most wood, and a sign will say "Future Home of Mt. Something-or-Other Baptist Church," and I don't feel so bad. At least the frame is wood, I tell myself, still pine pounded together with tenpenny nails, even if it is a nail gun and not a man's sweat that makes them hold together in the wind.

But I guess I will go to my grave believing that a church should be wooden and white and have a steeple on it. I don't think about dying much, but I think maybe I would like to have my funeral in a wooden church. I would like to be buried beside one so that maybe, when He comes down to take the faithful up with Him into the sky, He will snatch me up, too.

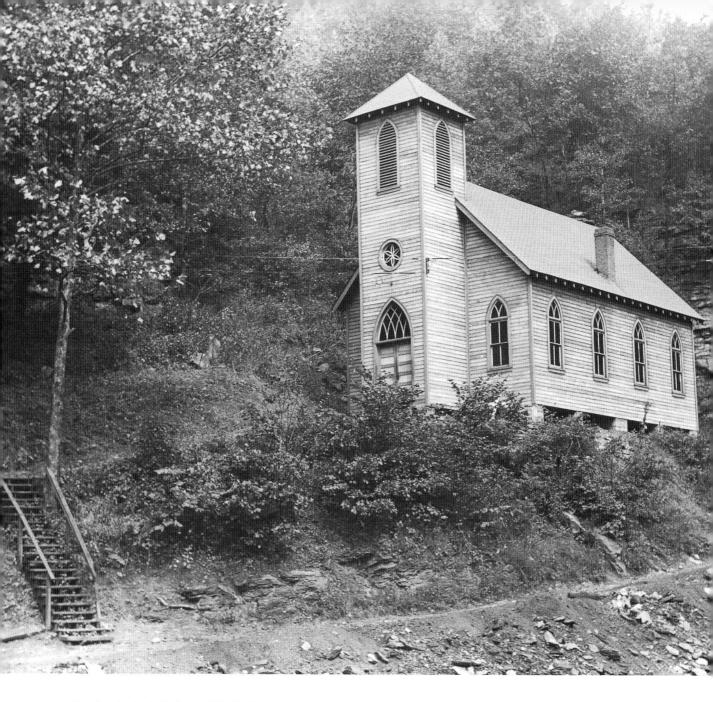

Church and union hall, Caples, West Virginia

*I*t was wood and it was white, and it was balanced like a box on upturned native stones. Its back snuggled close into the brow of a little hill, and the front, because it was level and true, stood several steps above the ground. It had no underpinning; roaming dogs and wind could course freely under the floor and around the supporting pillars. . . . The steeple had no ornamental frills but was proportioned well to the size of the building, and it housed an ancient iron bell that compensated in clanging volume for its lack of timbre and tone. It was a one-room building, but should anyone think it crude or spartan, let it be quickly known that this was the House of the Living God.

—*from* THE WHISPER OF THE RIVER, *by Ferrol Sams*

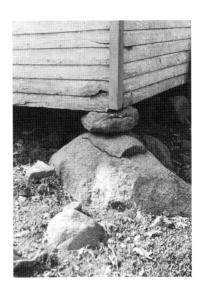

Church cornerstone, Nicholson Hollow, Virginia

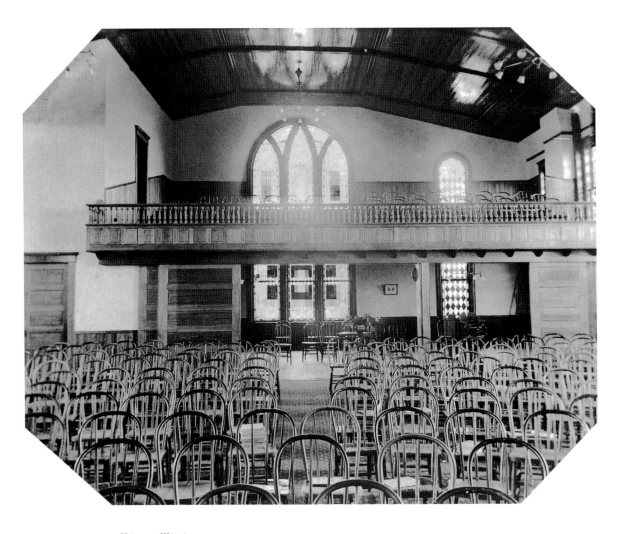

Chicago, Illinois

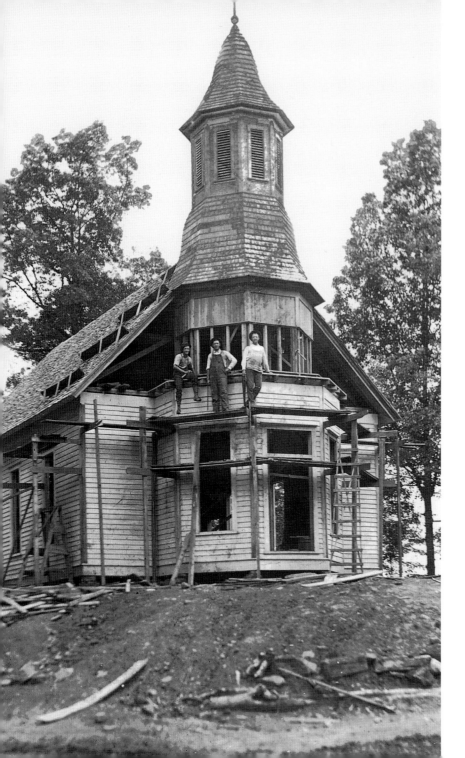

Grandpa's daddy raised that house out of his own oaks, pines, and cedars, and then he raised the church. He'd preach in the church on Sunday and the rest of the week he could stand on his own front porch and have it to look at.

—*from* LOSING BATTLES, *by Eudora Welty*

Western North Carolina

Leaving for church, Milton, North Dakota

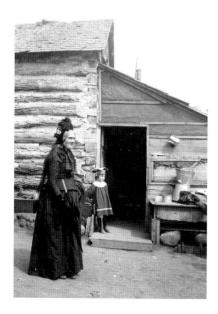

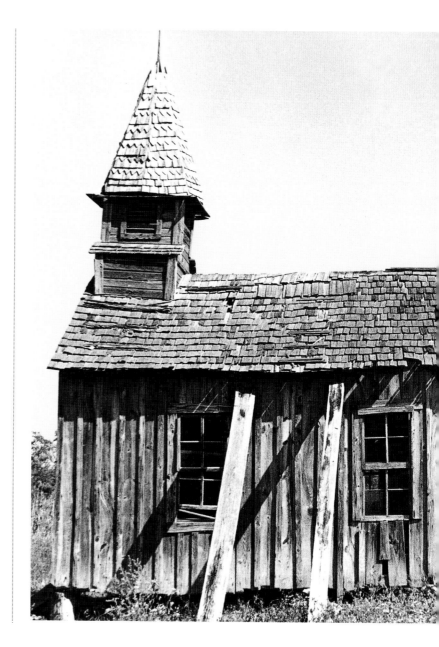

When Bernice said *we,* she meant Honey and Big Mama, her lodge, or her church.

—*from* THE MEMBER OF THE WEDDING, *by Carson McCullers*

Louisiana

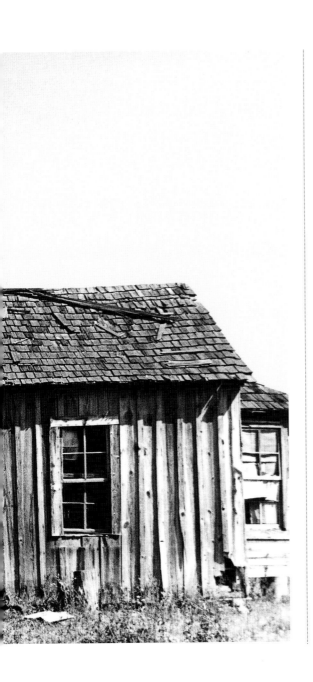

I know I am deathless,
I know this orbit of mine cannot be swept
 by a carpenter's compass,
I know I shall not pass like a child's carlacue
 cut with a burnt stick at night.

—*from* "SONG OF MYSELF," *by Walt Whitman*

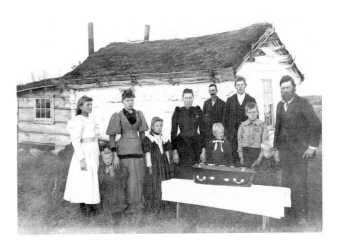

Funeral at pioneer church, North Dakota

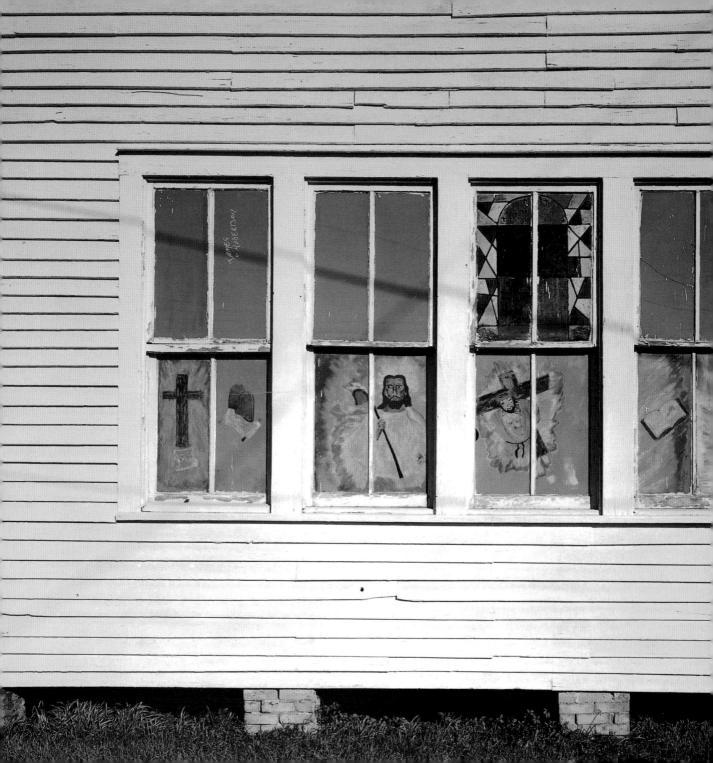

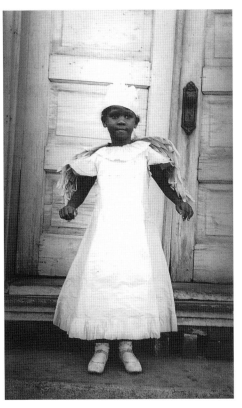

*H*ere is the church,

here is the steeple,

Open the doors,

and see all the people.

—*Anonymous*

Indianola, Mississippi

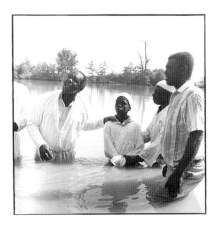

WHEN WE GOT TO the edge of the pond where Reverend Tyson was standing with two deacons, we were told to line up. I looked over at the crowd and saw that they had spread out so everyone could see better. There were a lot more people than I had thought. Seeing all those brightly colored dresses and hats, the long earrings, beads, and fancy hairdos, the blood-red lipstick laid on so thick that on some lips it looked purple made me even more aware that we were all dressed in white, even the boys. I felt like a stuffed white rabbit in an Easter parade.

—*from* COMING OF AGE IN MISSISSIPPI, *by Anne Moody*

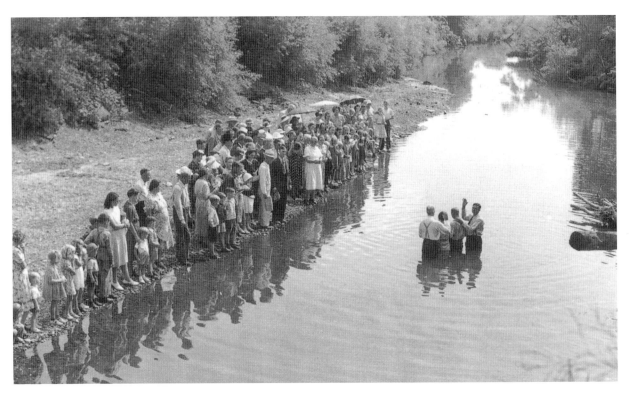

Triplett Creek, Kentucky

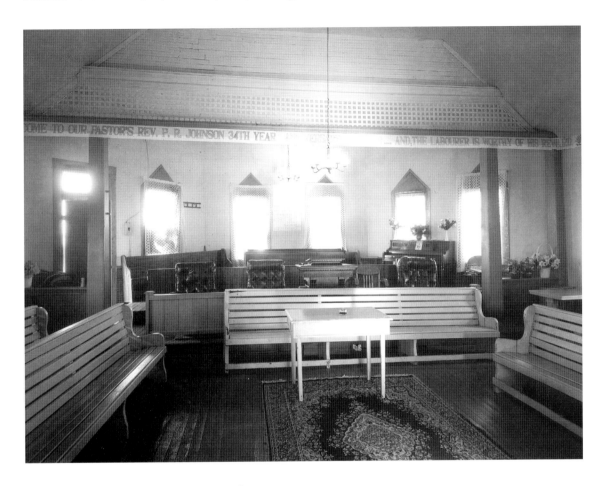

Ay, call it holy ground,

The soil where first they trod!

They have left unstained what there they found—

Freedom to worship God.

—*from "THE LANDING OF THE PILGRIM FATHERS," by Felicia Dorothea Hemans*

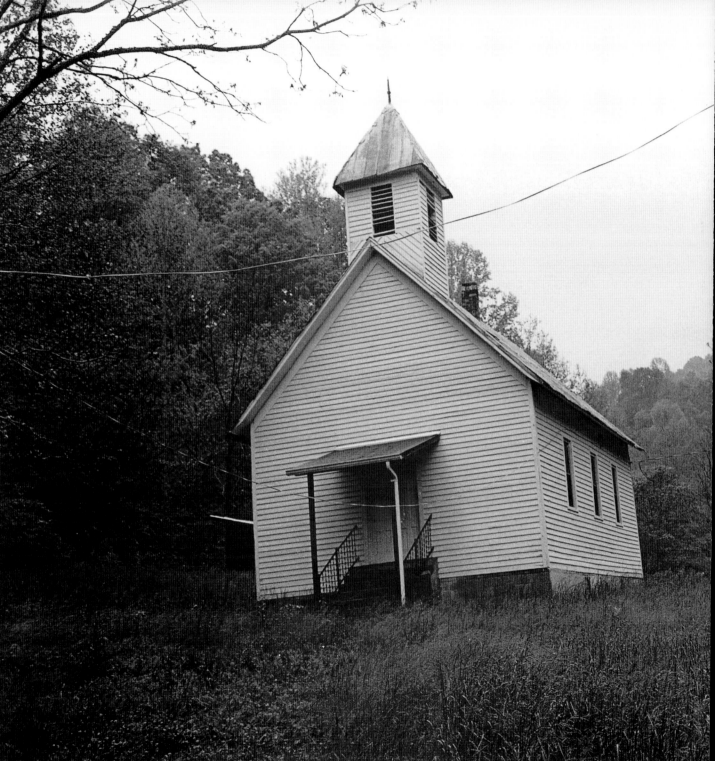

Ye have sown much, and
bring in little; ye eat, but ye
have not enough; ye drink,
but ye are not filled with drink;
ye clothe you, but there is
none warm; and he that earneth
wages earneth wages *to put it*
into a bag with holes.

Thus saith the LORD of
hosts; Consider your ways.

Go up to the mountain, and
bring wood, and build the house;
and I will take pleasure in it,
and I will be glorified, saith
the LORD.

—*from Haggai 1:6–8*

Madison County, North Carolina

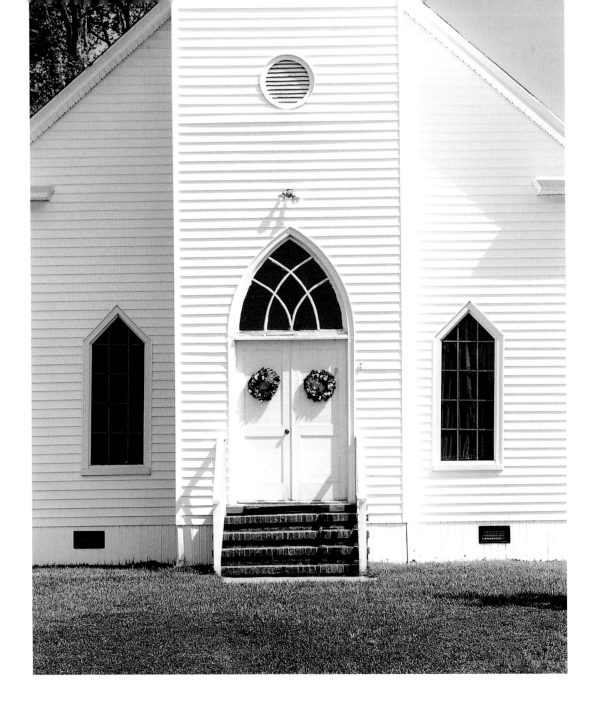

Durham, North Carolina

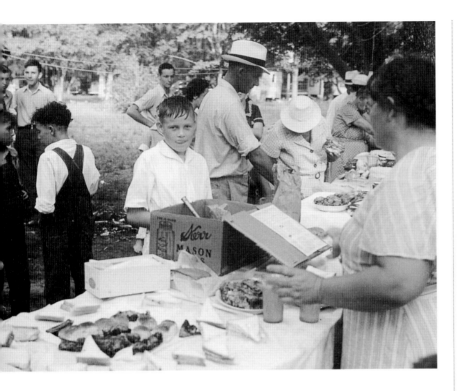

"Answer the gentleman, Thomas—don't be afraid."

Tom still hung fire.

"Now I know you'll tell *me*," said the lady. "The names of the first two disciples were—"

"DAVID AND GOLIATH!"

Let us draw the curtain of charity over this scene.

—*from* TOM SAWYER, *by Mark Twain*

Little Zalph Loggins finally found a piece of gum under the pew that he *could* get his fingernail under. He popped it off, looked at it, and decided not to chew it. Then he wondered what kind it might be and decided to go ahead. He put it in his mouth to see if it was Juicy Fruit. It was Dentyne he believed, so he took it back out and tried to stick it back under the pew. It wouldn't hold. He put it in a hymnbook.

—*from* WHERE TROUBLE SLEEPS, *by Clyde Edgerton*

Bardstown, Kentucky

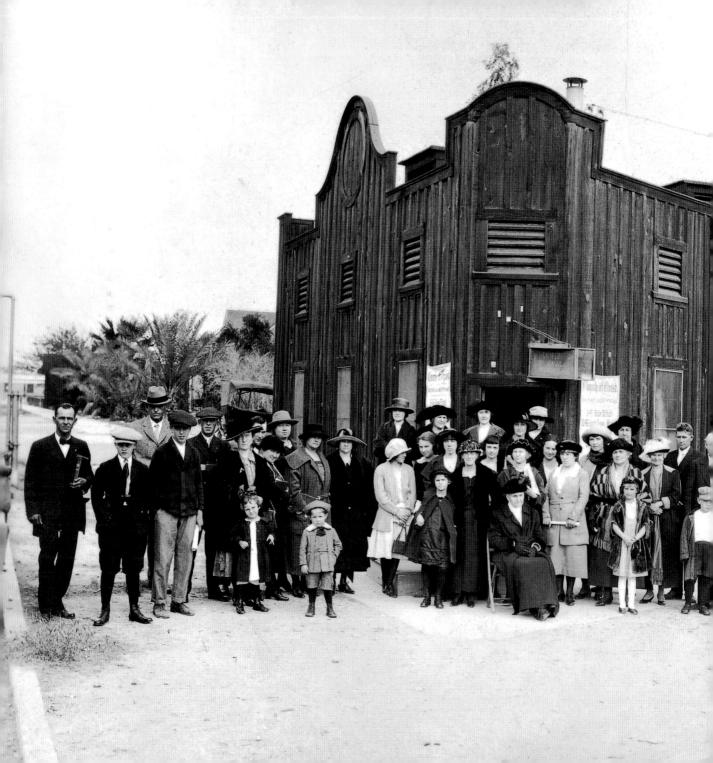

*E*veryone had always said that John
would be a preacher when he grew up,
just like his father. It had been said
so often that John, without ever thinking
about it, had come to believe it himself.
Not until the morning of his fourteenth
birthday did he really begin to think about
it, and by then it was already too late.

—*from* GO TELL IT ON THE MOUNTAIN,
by James Baldwin

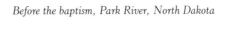

Triangle Church, Yuma, Arizona

LIKE MOST OLD FASHIONED pulpits, it was a very lofty one, and since a regular stairs to such a height would, by its long angle with the floor, seriously contract the already small area of the chapel, the architect, it seemed, had acted upon the hint of Father Mapple, and finished the pulpit without a stairs, substituting a perpendicular side ladder, like those used in mounting a ship from a boat at sea. The wife of a whaling captain had provided the chapel with a handsome pair of red worsted man-ropes for this ladder, which, being itself nicely headed, and stained with a mahogany color, the whole contrivance, considering what manner of chapel it was, seemed by no means in bad taste. Halting for an instant at the foot of the ladder, and with both hands grasping the ornamental knobs of the man-ropes, Father Mapple cast a look upwards, and then with a truly sailor-like but still reverential dexterity, hand over hand, mounted the steps as if ascending the main-top of his vessel.

—*from* MOBY DICK,
by Herman Melville

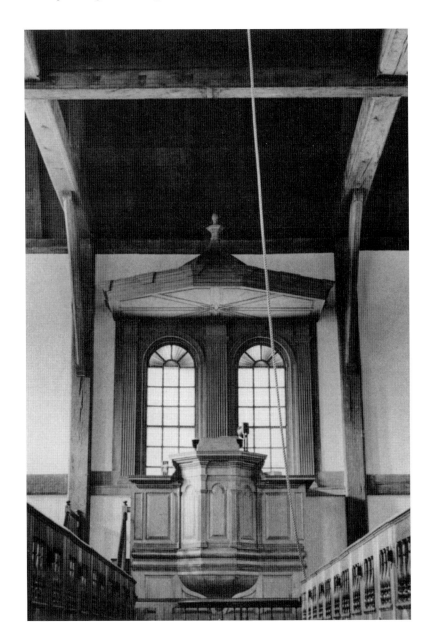

St. Peter's Catholic Church, Kahalu, Hawaii

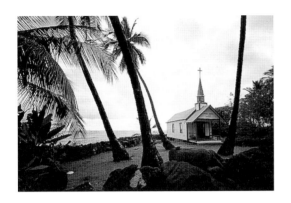

*I*n this same New Bedford there stands a
Whaleman's Chapel, and few are the moody
fishermen, shortly bound for the Indian Ocean
or Pacific, who fail to make a Sunday visit to
the spot. I am sure that I did not.

—*from* MOBY DICK, *by Herman Melville*

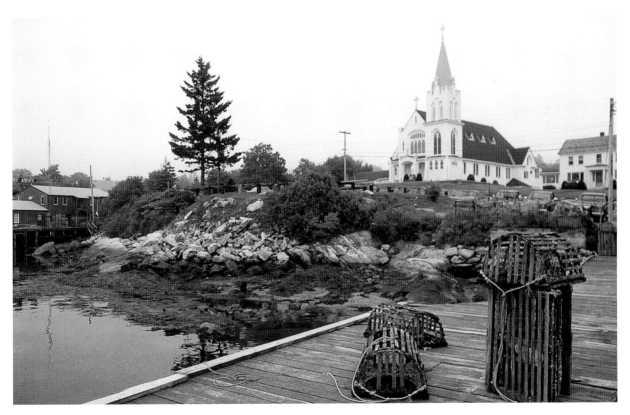

Boothbay, Maine

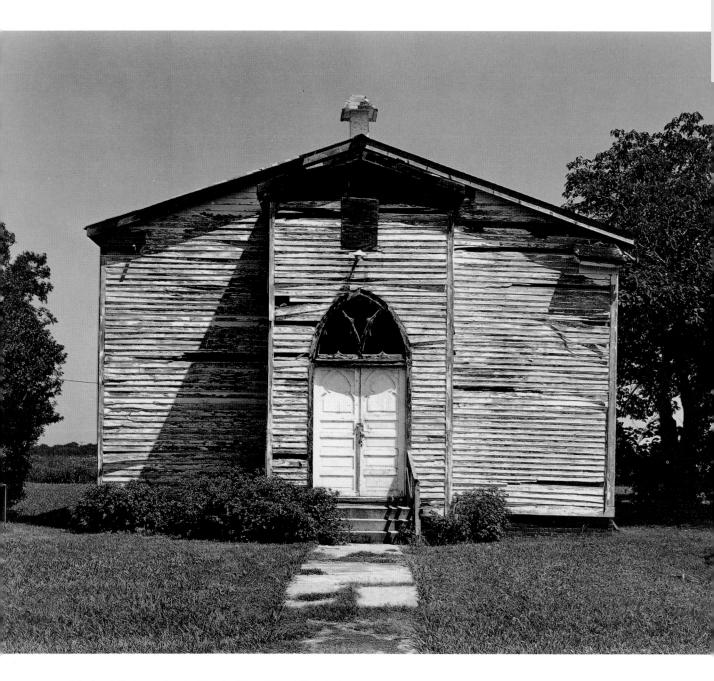

Mt. Airy Missionary Baptist Church, Friars Point, Mississippi

Always contrive to come before Service begins—Which You may do, as We begin so late. 'Tis but putting and getting things in Order over Night—Whereas many will hardly set about it till Sunday Morning. Contrive too, to go as early as possible to rest on Saturday Night so that You may rise early and refresh'd on the Lords day and not be hurry'd in dressing, and ordering Matters. The coming late to Sermon discourages People, for lack of Company—and coming in after Service is begun is very troublesome—Disturb both me and ev'ry One and should be avoided as much as possible—But if it is unavoidable, pray enter leisurely—tread softly—nor disturb any who are on their Knees or are intent on their Devotions. Bring no Dogs with You—they are very troublesome—and I shall inform the Magistrate of those who do it, for it is an Affront to the Divine Presence which We invoke, to be in the midst of Us, and to hear our Prayers, to mix unclean things with our Services.

—from "ON CORRECT BEHAVIOR IN CHURCH," by the Reverend Charles Woodmason, 1770

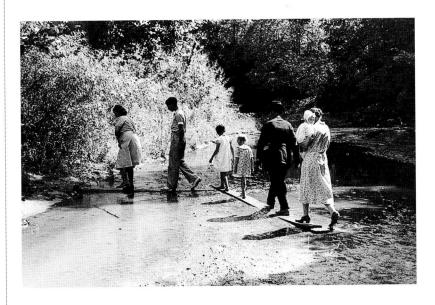

On the way to the baptism, Moorehead, Kentucky

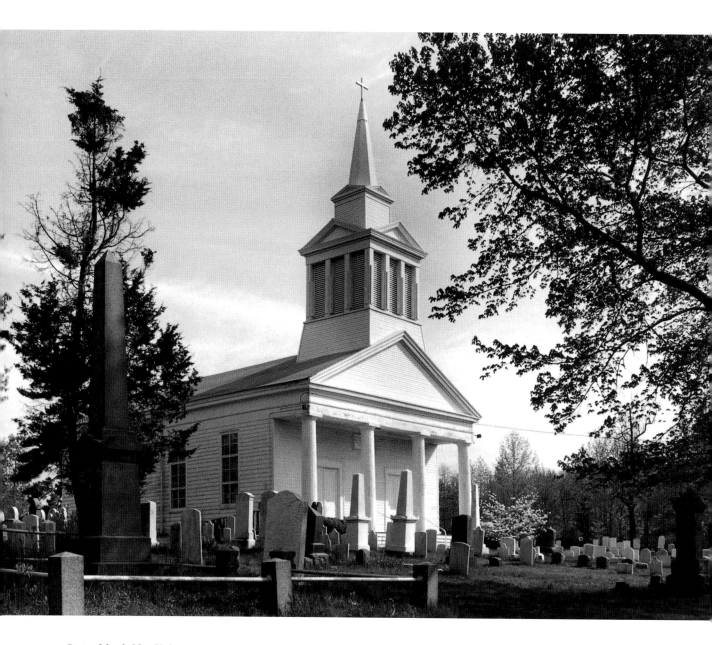

Staten Island, New York

O THAT THE SPIRIT could remain
tinged but untarnished by its strain!
Better dressed and stacking birch,
or lost with the Faithful at Church—
anywhere, but somewhere else!
And now the new electric bells,
clearly chiming, "Faith of our fathers,"
and now the congregation gathers.

—*from "WAKING EARLY SUNDAY MORNING," by Robert Lowell*

Great Hills Baptist Church, Austin, Texas

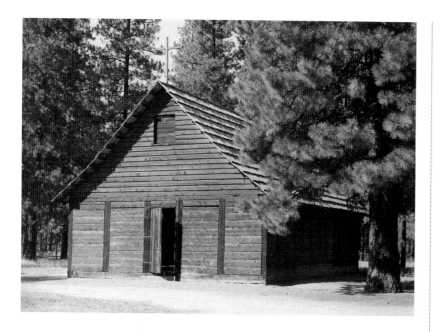

THERE IS AN ALTERATION made in the town in a few months that strangers can scarcely conceive of; our church I believe was the largest in New England before, but persons lately have thronged in, so that there are very few adult persons left out. There have been a great multitude hopefully converted; too many, I find, for me to declare abroad with credit to my judgment. The town seems to be full of the presence of God; our young people when they get together instead of frolicking as they used to do are altogether on pious subjects; 'tis so at weddings and on all occasions. The children in this and the neighboring towns have been greatly affected and influenced by the Spirit of God, and many of them hopefully changed; the youngest in this town is between nine and ten years of age. Some of them seem to be full of love to Christ and have expressed great longings after Him and willingness to die, and leave father and mother and all things in the world to go to him, together with a great sense of their unworthiness and admiration at the free grace of God towards them. And there have been many old people, many above fifty and several near seventy, that seem to be wonderfully changed and hopefully newborn. The good people that have been formerly converted in the town have many of them been wonderfully enlivened and increased.

—*from "LETTER TO REV. DR. BENJAMIN COLMAN," a letter from Jonathan Edwards describing the Great Awakening*

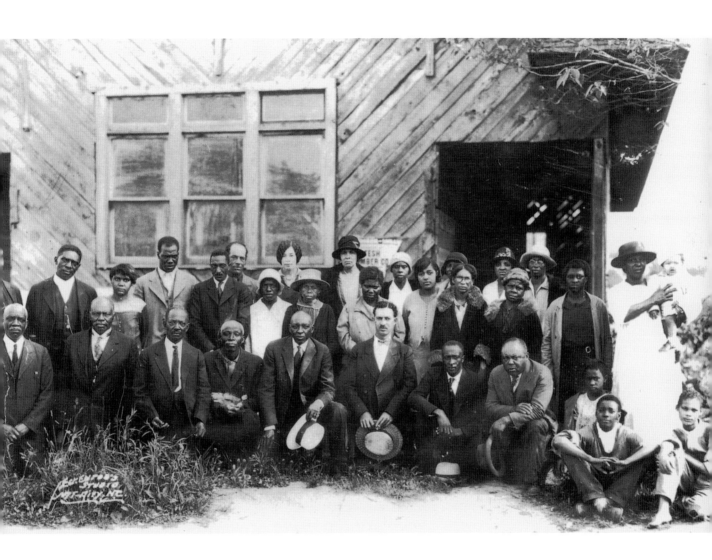

Eastern North Carolina

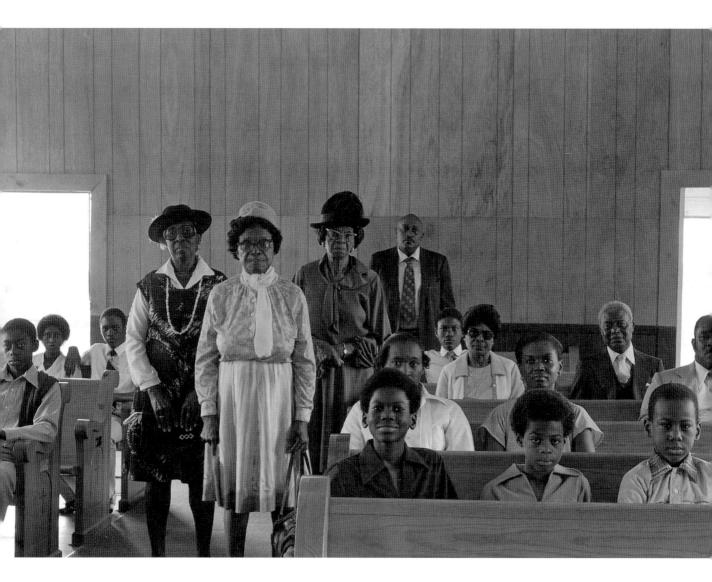

Pilgrim Rest Church, Decatur County, Georgia

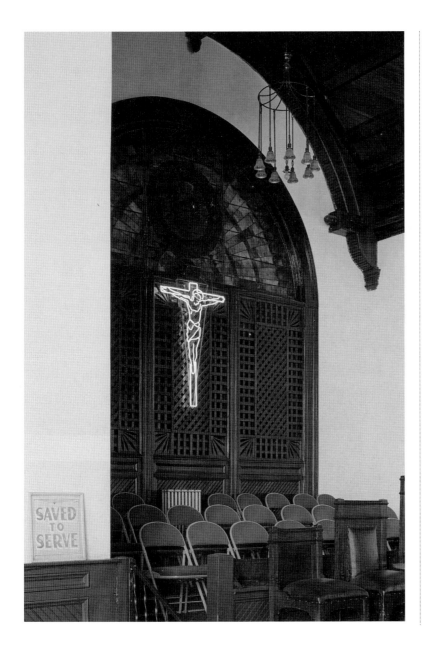

First AB Church, Bainbridge, Georgia

"Church! Tonight, as I have told the world, I'm gonna die. I'm gonna be nailed to this cross and let the breath pass from me. But tomorrow, Monday night, August the twenty-first, at twelve p.m., I am coming back to life. Amen! After twenty-four hours on the cross, hallelujah! And all the city of St. Louis can be saved—if they will just come out to see me. Now, before I mounts the steps to the cross, let us sing for the last time "In His Hand"—'cause I tell you, that's where I am! As we sing, let everybody come forward to the collection table and help this church before I go. Give largely!"

—*from "ROCK, CHURCH,"*
by Langston Hughes

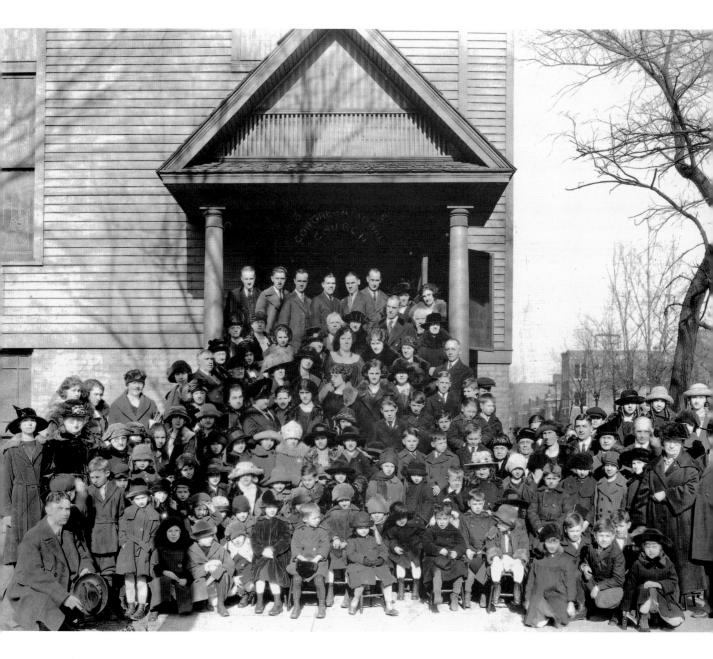

Chicago, Illinois

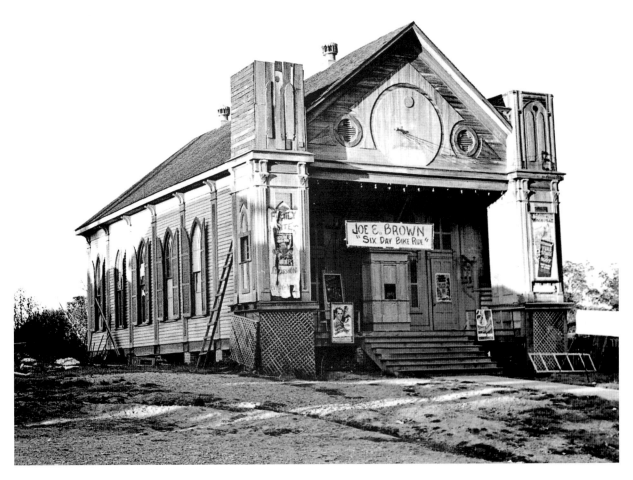

By THE TIME MASS begins we are packed in like sardines. A woman comes up the aisle, leans over and looks down our pew. She gives me an especially hard look. I do not budge. It is like the subway. Roy Smith, who got home just in time to change to a clean perforated shirt, gives up his seat to a little girl and kneels in the aisle with several other men, kneels on one knee like a tackle, elbow propped on his upright knee, hands clasped sideways. His face is dark with blood, his breath whistles in his nose as he studies the chips in the terrazzo floor.

—*from* THE MOVIEGOER, *by Walker Percy*

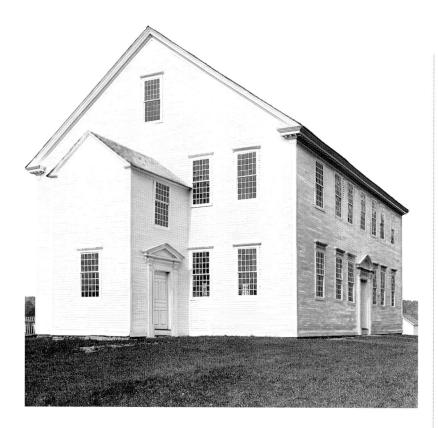

Oldest church in Vermont,
Rockingham, Vermont, 1787

"OUR PARSON HAS GONE MAD!" cried Goodman Gray, following him across the threshold.

A rumor of some unaccountable phenomenon had preceded Mr. Hooper into the meeting-house, and set all the congregation astir. Few could refrain from twisting their heads towards the door; many stood upright, and turned directly about; while several little boys clambered upon the seats, and came down again with a terrible racket. There was a general bustle, a rustling of the women's gowns and shuffling of the men's feet, greatly at variance with that hushed repose which should attend the entrance of the minister. But Mr. Hooper appeared not to notice the perturbation of his people. He entered with an almost noiseless step, bent his head mildly to the pews on each side, and bowed as he passed his oldest parishioner, a white-haired great-grandsire, who occupied an arm-chair in the centre of the aisle. It was strange to observe, how slowly this venerable man became conscious of something singular in the appearance of his pastor. He seemed not fully to partake of the prevailing wonder, till Mr. Hooper had ascended the stairs, and showed himself in the pulpit, face to face with his congregation, except for the black veil.

—*from "THE MINISTER'S BLACK VEIL," by Nathaniel Hawthorne*

I believe in you my soul, the other I am must not abase itself to you,

And you must not be abased to the other.

—*from "Song of Myself," by Walt Whitman*

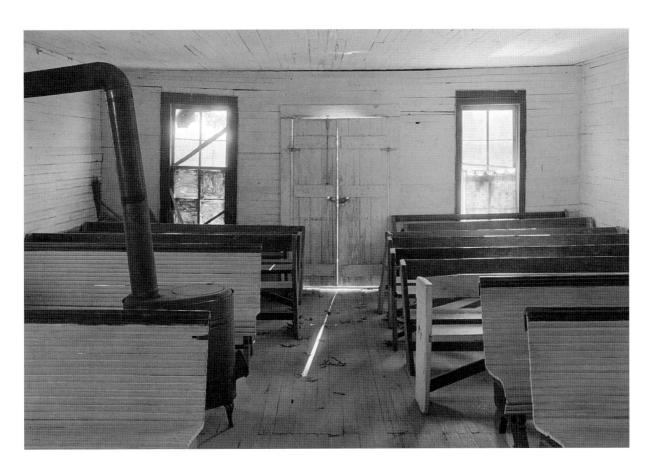

Mt. Horum Church, Decatur County, Georgia

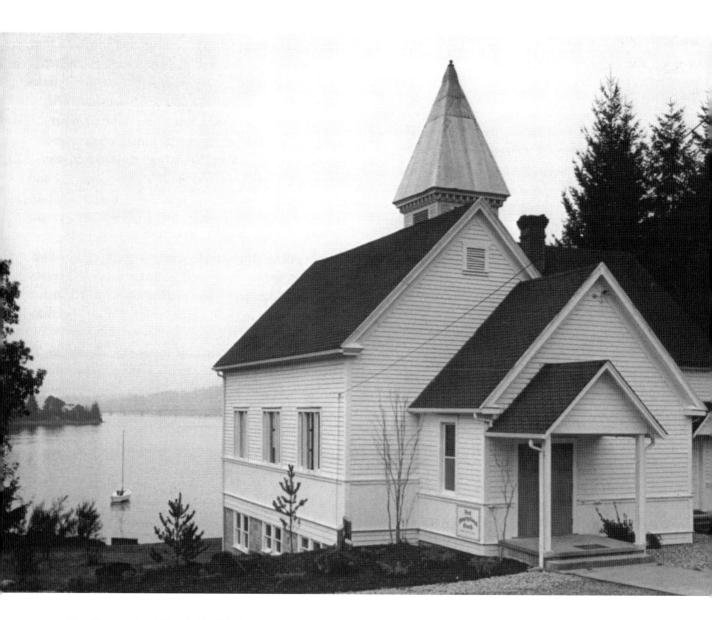

First Congregational Church, Fox Island, Washington

ROSACOKE REMEMBERED IN THE vestibule that she hadn't been here since the day she slipped off with Mildred and came to the meeting where Aunt Mannie Mayfield stood at age eighty and named the fathers of all her children, far as she could recall. Rosacoke looked round now and the same three things to notice were there—a bell rope hanging from the steeple for anybody to pull, and a gray paper hornets' nest (built in the window by mistake during the war but deserted now far as the eye could see though nobody would tear it down for fear one hornet might be there still, getting older and meaner), and by the open door to the auditorium, a paper bag nailed to the wall with a note saying, *Kindly Leave Gum Here.*

—*from* A LONG AND HAPPY LIFE, *by Reynolds Price*

Leaving church, Linworth, Ohio

At last came the Twenty-third Psalm in all its aching familiarity, and Dandy felt his mouth moving to every one of those words he did not trust, words that after all these years were still perfectly arranged in storage deep in his throat.

". . . and I will dwell in the house of the Lord for ever."

—*from* SOULS RAISED FROM THE DEAD, *by Doris Betts*

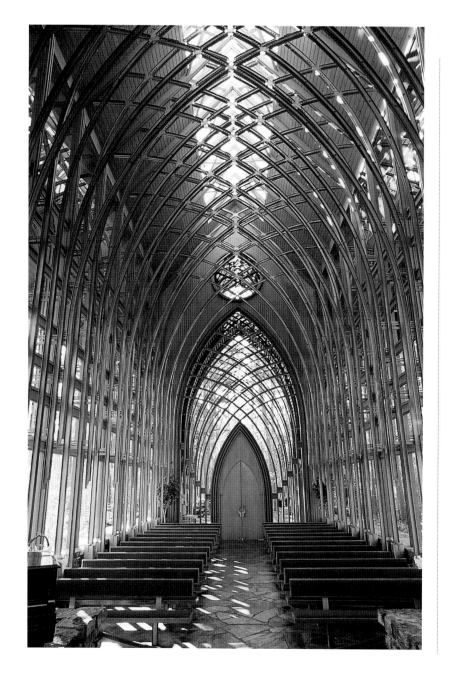

THE SMALL COUNTRY CHURCH
is packed with his neighbors, all
of whom are wearing clean collars.
The giving out of the hymn
number causes them to rise and
add the droning of their country
voices to the wheezing of the
little organ. Since the preacher
said that the point of the parables
is mysterious and needs explaining,
they have no choice but to believe
him. The details—the great supper,
the lost lamb, the unproductive
vineyard, the unjust steward, the
sower, and the seed sown secretly—
they are familiar with and under-
stand. Above the transparent dome
they live and work under there is
another even grander where they
will reside in mansions waiting to
receive them when they are done
with farming forever.

—*from* SO LONG, SEE YOU
TOMORROW, *by William Maxwell*

Cooper Memorial Chapel,
Bella Vista, Arkansas

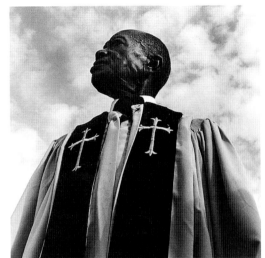

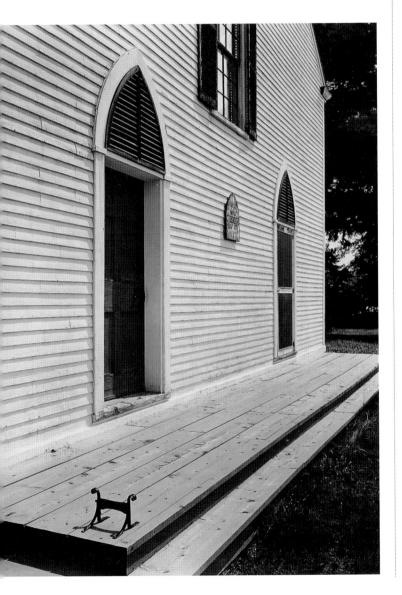

I felt like a man whose job
it was to close up a church.
In this passion, that was
the word for a man's house.
The citadel, the chapel,
of his character.

—*from* THE HOME PLACE,
by Wright Morris

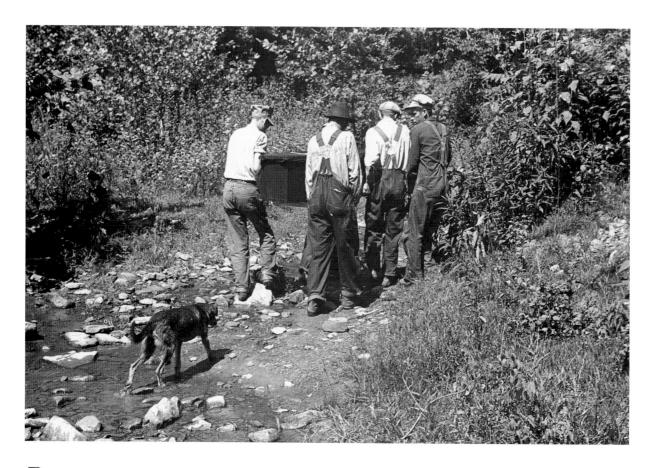

*D*addy never attended no church, so we didn't know where we was going to have the funeral at, even though we grew up right there in Hungry Neck, one block from Second Zion. That's the church and Sunday School we went to, but Daddy never went. We didn't know what preacher to call, we said golly, we can't call nobody because he never served time in the church. We had to try to find people to sing, the whole works.

—*from* GAL, *by Ruthie Bolton*

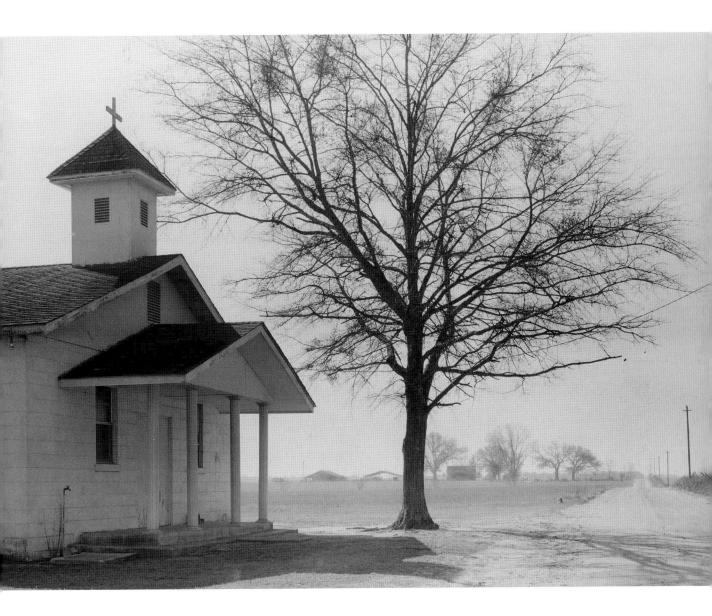

Decatur County, Georgia

THE CHURCH, THOUGH, WAS already in flames when I drove up, and I stepped out to hear the priest lift his voice above all the sobbing and weeping. "There's a great sea crashing over this nation," the priest called out, wiping away his own tears, the only one in that field turned not toward the fire but away from it, as though he'd already seen the flames and understood their meaning, as though he had emerged from the fire itself to tell its story. "There's a great sea washing everything clean," he shouted. "It's a sea, my brothers and sisters, whose waves won't subside at the empty threat of one small fire. It's a sea whose waves won't subside at a hundred burning churches or a thousand burning crosses or a hundred thousand more."

—*from* THE WRECKED, BLESSED BODY OF SHELTON LAFLEUR, *by John Gregory Brown*

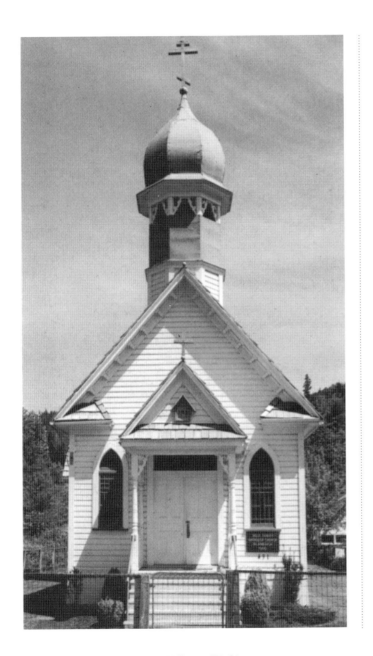

Holy Trinity Orthodox Church, Wilkeson, Washington

They was all Moslems, Tom said, and when I asked him what a Moslem was, he said it was a person that wasn't a Presbyterian. So there is plenty of them in Missouri, though I didn't know it before.

—*from* TOM SAWYER ABROAD,
by Mark Twain

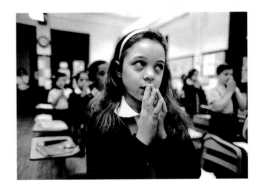

*School and Church of the Holy Name,
New York, New York*

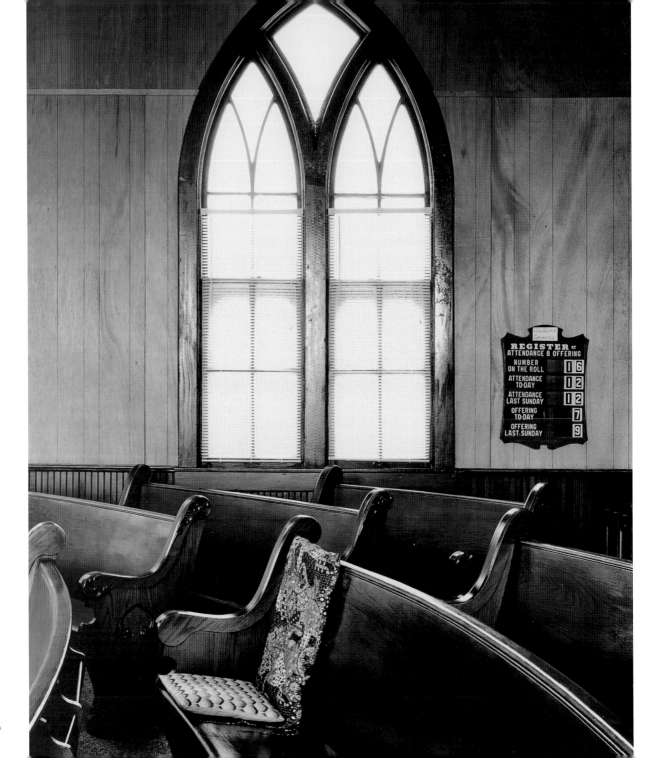

*T*hings were done very literally. One thing they did at that church that I'll never forget, was that they had a big ply-board thing, in the front of the church, full of light bulbs. This was at regular church. If you were present, you and your family, you'd go up and screw in your light bulb. And it would turn on. And over the top of the whole thing, it said, "Let Your Little Light Shine." And if you weren't there, it would be so obvious to everyone else in the congregation because your little light would not be shining.

—from an interview with Lee Smith, excerpted in THE CHRIST-HAUNTED LANDSCAPE

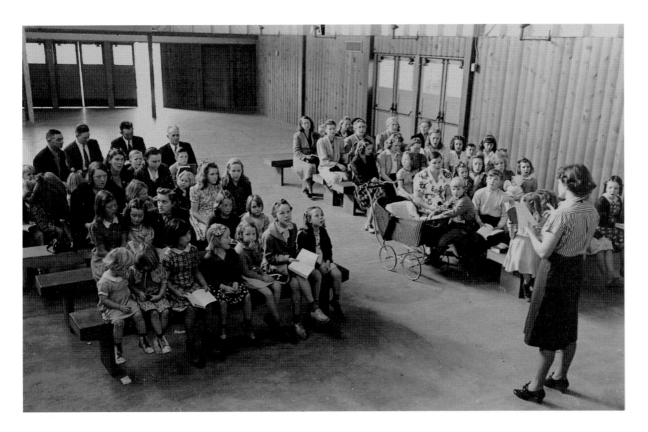

Sunday School, Woodville, California

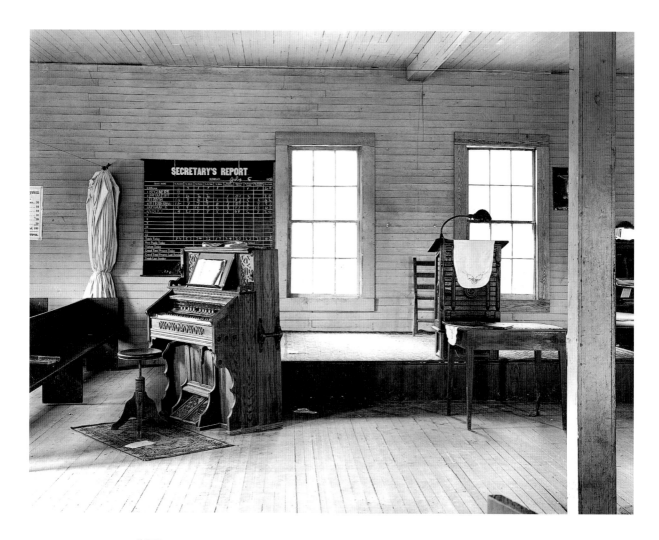

"*T*he truth is, cathedrals don't mean anything special to me."

—*from* CATHEDRAL, *by Raymond Carver*

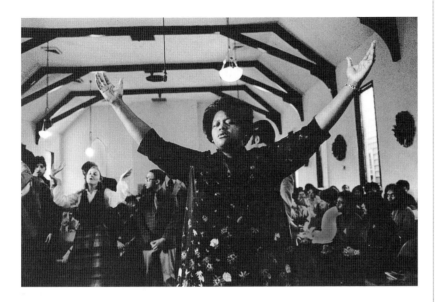

"Bless you, sister, the Lord has made you a vessel for his Word tonight. Through you has flowed the sweet honey from the rock and in your mouth is the light of stars."

—*from* THE TRUEST PLEASURE, *by Robert Morgan*

Deeper Life Christian Fellowship, Richmond Hill, New York

I FOLLOWED THEM AND we sat like wet ducks on a bench facing the congregation. Some part of me was cursing. A low, soft hymn began.

This may be the last time, I don't know . . .

They sang it, hummed it, crooned it, moaned it, implying in sweet, frightening tones that if we did not join the church then and there we might die in our sleep that very night and go straight to hell. The church members felt the challenge and the volume of song swelled. Could they sing so terrifyingly sweet as to make us join, burst into tears and drop to our knees? A few boys rose and gave their hands to the preacher. A few women shouted and danced with joy. Another hymn began.

It ain't my brother, but it's me, oh, Lord,
Standing in the need of prayer . . .

—*from* BLACK BOY, *by Richard Wright*

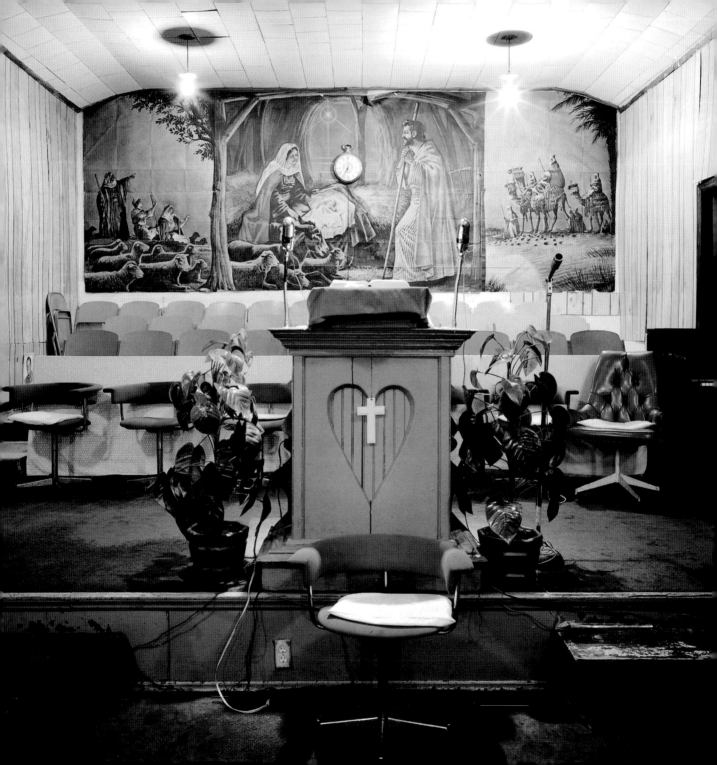

I LOOKED AT BABY JESUS with the tenderest of looks I could manufacture and all the while my antagonist, Cheryl, had her hand on my shoulder digging me with her fingernails and a staff in her right hand. A record went on the phonograph and "Noel" began to play. The Wise Men came in most solemnly. Leroy carried a big gold box and presented it to me. I said, "Thank you, O King, for you have traveled far." And Cheryl, that rat, says, "And traveled far," as loud as she could. She wasn't supposed to say that. She started saying whatever came in her head that sounded religious. Leroy was choking in his beard and I was rocking the cradle so hard that the Jesus doll fell on the floor. So I decided two can play this game. I leaned over the doll and said in my most gentle voice, "O, dearest babe, I hope you have not hurt yourself. Come let Mother put you back to bed." Well, Leroy was near to dying of perplexity and he started to say something too, but Cheryl cut him off with, "Don't worry, Mary, babies fall out of the cradle all the time." That wasn't enough for greedy-guts, she then goes on about how she was a carpenter in a foreign land and how we had to travel many miles just so I could have my baby. She rattled on and on. All that time she spent in Sunday School was paying off because she had one story after another. I couldn't stand it any longer so I blurted out in the middle of her tale about the tax collectors, "Joseph, you shut up or you'll wake the baby."

—*from* RUBYFRUIT JUNGLE,
by Rita Mae Brown

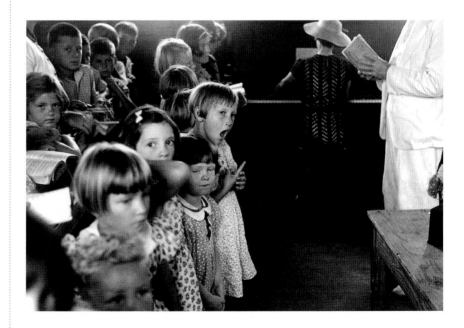

Sunday school, Penderlea Homesteads, North Carolina

*I*t was his first Sunday in town. He had come because he felt as bound to see the Southern Baptists as he would, in Mexico, the Aztec ruins. And he was enjoying himself, singing the hymns with such vigor that people were twisting around to stare.

—*from* "THE GLORY OF HIS NOSTRILS," *by Doris Betts*

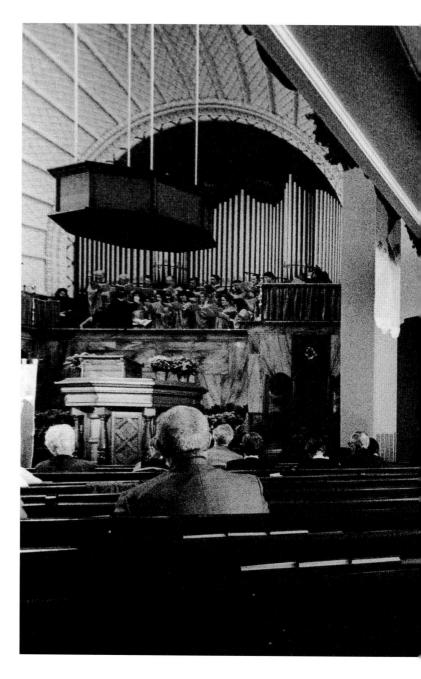

University Baptist Church, Austin, Texas

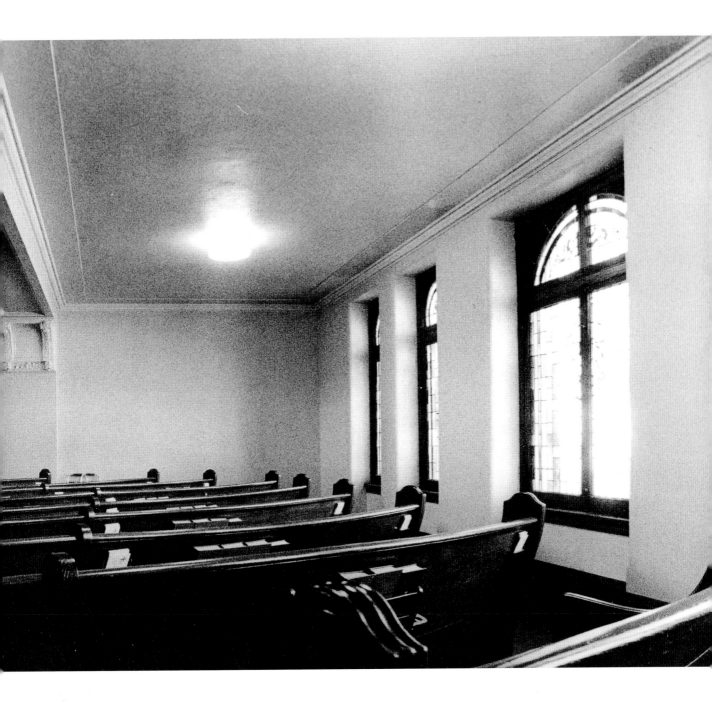

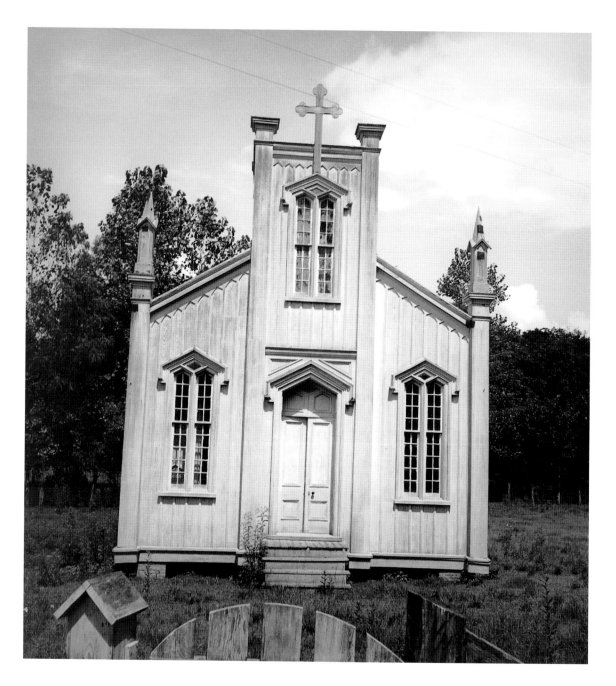

Catholic church, Rodney, Mississippi

WHILE THE SOUNDS in the church were increasing, Elder Thomas made the regrettable mistake of increasing his volume too. Then suddenly, like a summer rain, Sister Monroe broke through the cloud of people trying to hem her in, and flooded up to the pulpit. She didn't stop this time but continued immediately to the altar, bound for Elder Thomas, crying "I say, preach it."

Bailey said out loud, "Hot dog" and "Damn" and "She's going to beat his butt."

But Reverend Thomas didn't intend to wait for that eventuality, so as Sister Monroe approached the pulpit from the right he started descending from the left. He was not intimidated by his change of venue. He continued preaching and moving. He finally stopped right in front of the collection table, which put him almost in our laps, and Sister Monroe rounded the altar on his heels, followed by the deacons, ushers, some unofficial members and a few of the bigger children.

Just as the elder opened his mouth, pink tongue waving, and said, "Great God of Mount Nebo," Sister Monroe hit him on the back of his head with her purse. Twice. Before he could bring his lips together, his teeth fell, no actually his teeth jumped, out of his mouth.

The grinning uppers and lowers lay by my right shoe, looking empty and at the same time appearing to contain all the emptiness in the world.

—*from* I KNOW WHY THE CAGED BIRD SINGS, *by Maya Angelou*

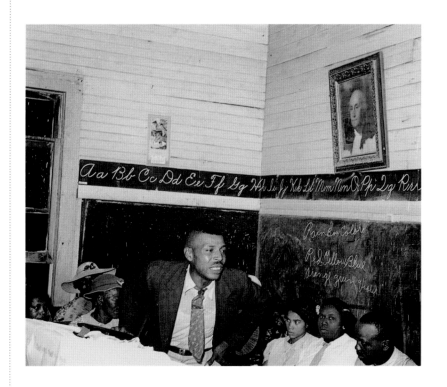

Revival meeting, La Forge, Missouri

"*T*his is the word, this is the message I bring to you tonight."

Fred Lee's words crackle through the speaker directly above Crystal's head. She feels as if electricity is shooting straight into her head and all down her body, crackling in every nerve. From her biology book she remembers the outline of the human body, sexless, a black outline on the white page, with the thin red lines of the nerves. A current arcs through her body, making her feel like she felt when she was with Mack— alive, fully alive and fully real, more than real.

"Now," whispers Fred Lee Sampson, "*now.* I ask you to bow your heads and let the sweet message of Jesus enter your hearts tonight."

—*from* BLACK MOUNTAIN BREAKDOWN, *by Lee Smith*

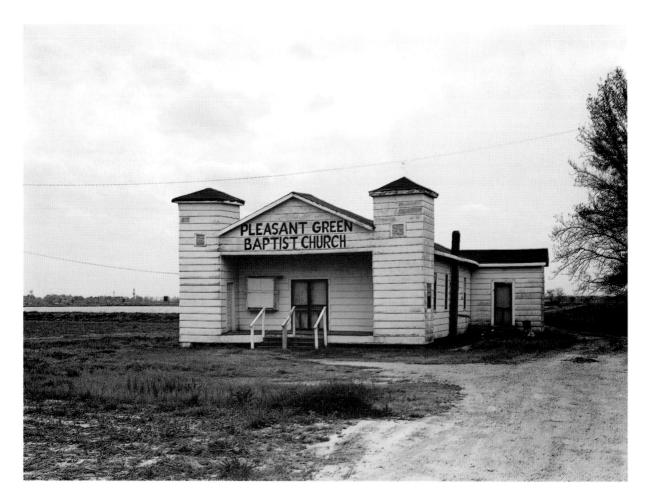

BROTHER JONES WAS RANTING on about a great war between Good and Evil, and how that comet was a messenger of Armageddon. The Good Lord aimed to wipe out the whole world, punish us poor sinners for good and all, leave just a few of the pure in heart to get the world cranked up again. By the time that man of God was done with us, the pure-in-hearts was the only ones breathing easy. But pure-in-hearts was never plentiful around the Bay, and once the sinners went to Hell, it might of got pretty lonesome around here, crying in the wilderness and all like that.

—*from* KILLING MR. WATSON, *by Peter Matthiessen*

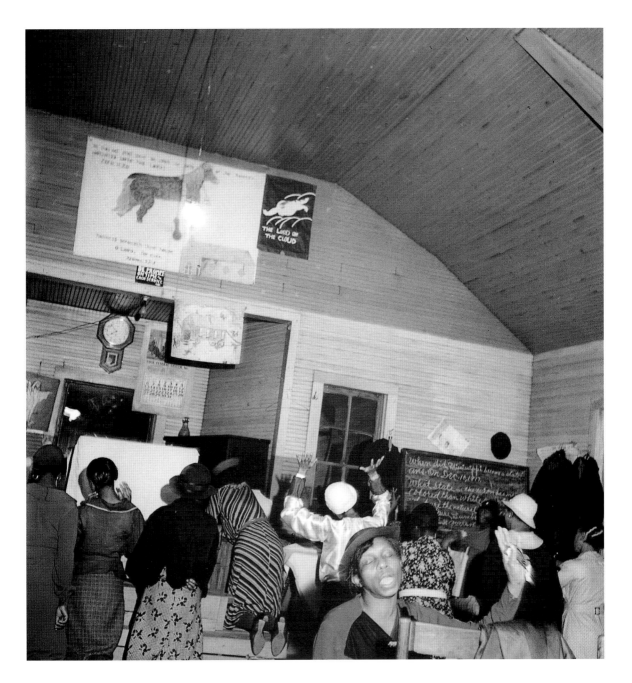

Holiness Church, Jackson, Mississippi

Thomas Slave Chapel, Bedford County, Virginia

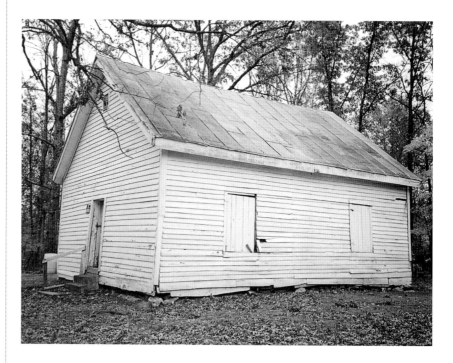

Go down, Moses,
'Way down in Egypt land,
Tell ole Pharaoh,
To let my people go.

—traditional spiritual

THE NEXT GALE THAT sweeps from the north will bring to our ears the clash of resounding arms! Our brethren are already in the field! Why stand we here idle? What is it that gentlemen wish? What would they have? Is life so dear, or peace so sweet, as to be purchased at the price of chains and slavery? Forbid it, Almighty God—I know not what course others may take; but as for me, give me liberty, or give me death!

—from a speech delivered in St. John's Church, Richmond, Virginia, by Patrick Henry, March 23, 1775

St. John's Church after the Union victory, Richmond, Virginia, 1865

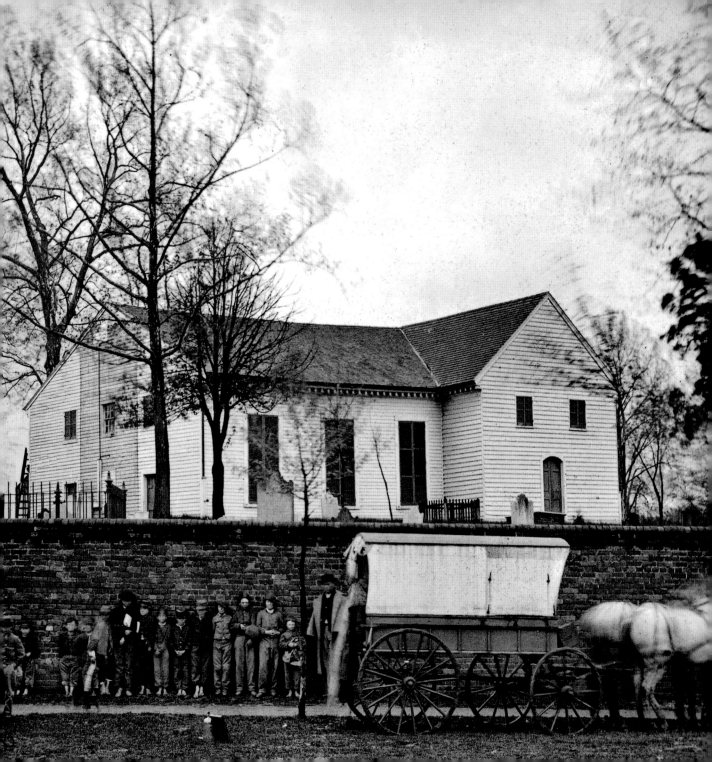

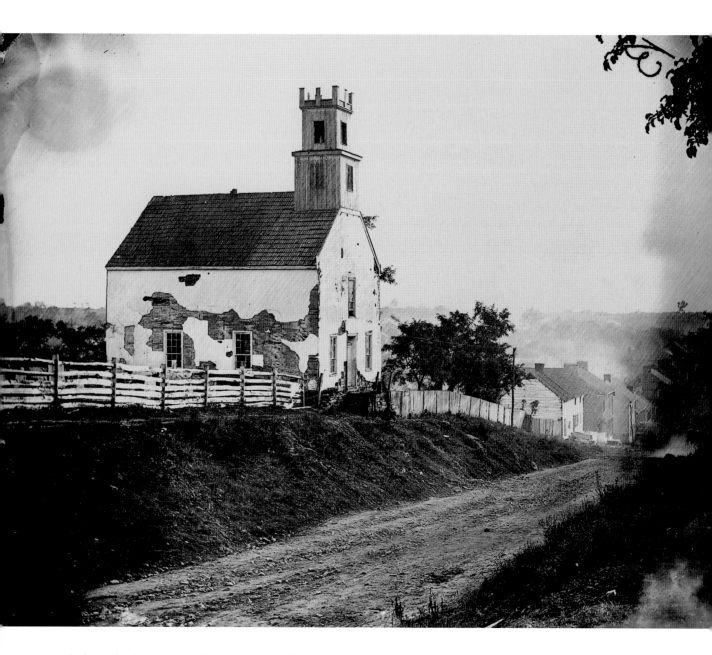

Lutheran church just after the Battle of Antietam, Sharpsburg, Maryland

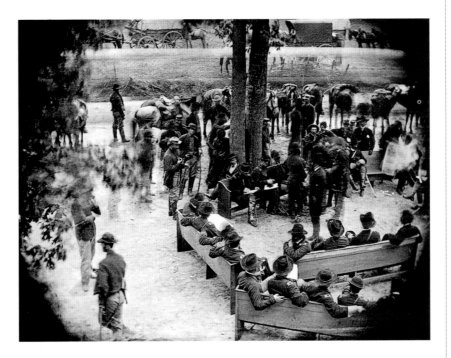

Whether thou standest charged with ten or but two talents, if thou huntest any for cause of *conscience,* how canst thou followest the *Lamb of God* who so abhorred that practice?

—*from* A CONFERENCE BETWEEN TRUTH AND PEACE, *by Roger Williams*

LET ME, BOYS, MY dear friends, express the hope that you may speedily be cured of your wounds, ready again to do willing service in the ranks of the glorious army that must be vigilant for some time yet, I fear, to defend, as Americans and Christians, the civilization you have so nobly saved from a ruthless foe. . . . Let us all join together in singing the hymn, *'Stand up, stand up for Jesus,'* which I am sure you all know."

The men got to their feet, except for a few who had lost their legs, and sang the first verse of the hymn unsteadily. The second verse petered out altogether, leaving only the "Y" man and the Reverend Dr. Skinner singing away at the top of their lungs.

—*from* THREE SOLDIERS, *by John Dos Passos*

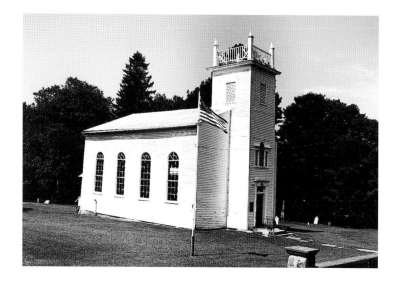

*D*emocracy is itself a religious faith. For some
it comes close to being the only formal religion
they have. And so when I see the first faint
shadow of orthodoxy sweep across the sky, feel
the first cold whiff of its blinding fog steal in
from sea, I tremble all over, as though I had just
seen an eagle go by, carrying a baby.

—*from* THE POINTS OF MY COMPASS, *by E. B. White*

Boy sitting in front of Sudley Church after the First Battle of Bull Run, 1861

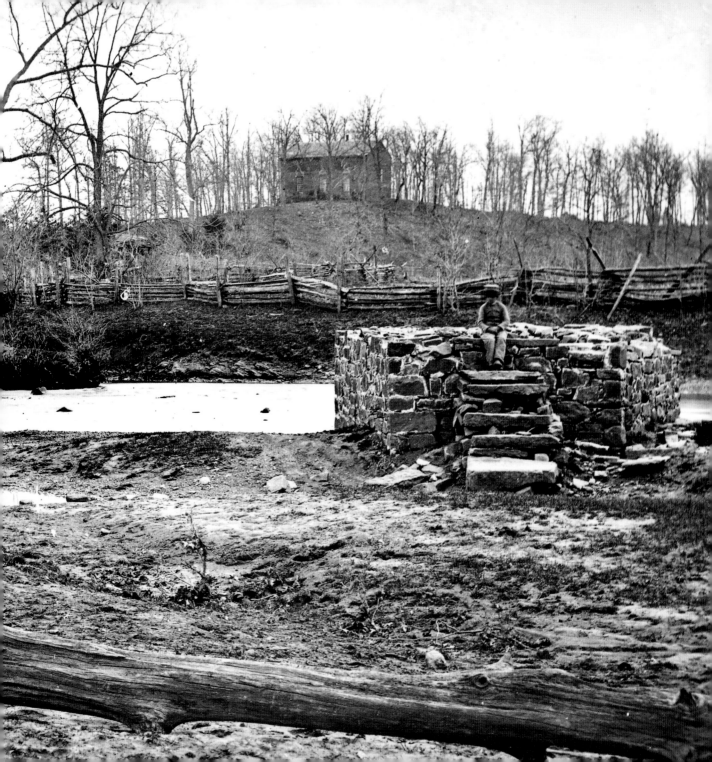

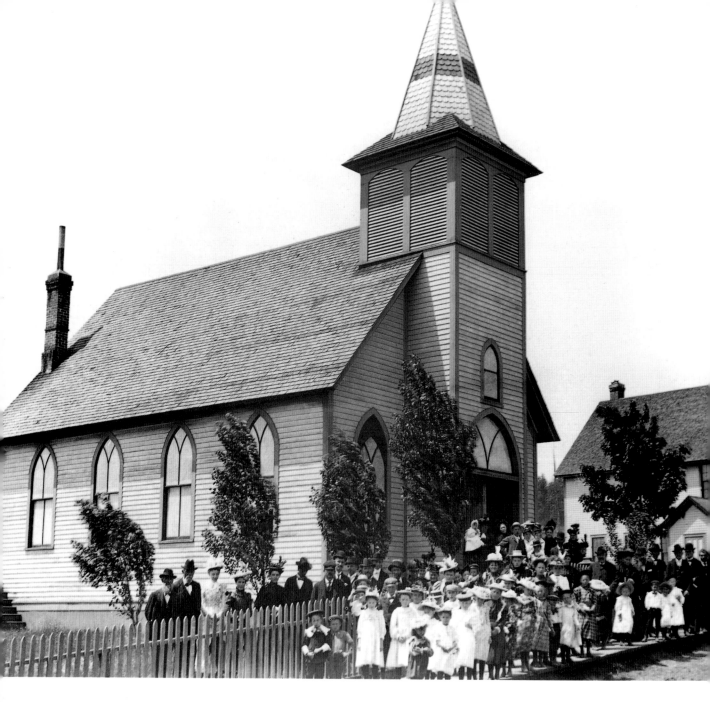

Millersburg, Michigan

Montesano United Methodist Church, Montesano, Washington

*A*nd when Jesus
beheld him, he said,
Thou art Simon
the son of Jona:
thou shalt be called
Cephas, which is
by interpretation,
A stone.

—*from* JOHN 1:42

"WE COULD GO SIT under the stage," Shannon suggested. "It's real nice under there."

It was nice, close and dark and full of the sound of people stomping on the stage. I put my head back and let the dust drift down on my face, enjoying the feeling of being safe and hidden, away from the crowd. The music seemed to be vibrating in my bones. *Taking your measure, taking your measure, Jesus and the Holy Ghost are taking your measure . . .*

—*from* BASTARD OUT OF CAROLINA, *by Dorothy Allison*

Church cornerstone, Adams County, Nebraska

In the black Protestant church I entered a new world: prim, brown, puritanical girls who taught in the public schools; black college students who tried to conceal their plantation origin; black boys and girls emerging self-consciously from adolescence; wobbly-bosomed black and yellow church matrons; black janitors and porters who sang proudly in the choir; subdued redcaps and carpenters who served as deacons; meek, blank-eyed black and yellow washerwomen who shouted and moaned and danced when hymns were sung; jovial, potbellied black bishops; skinny old maids who were constantly giving rallies to raise money; snobbery, clannishness, gossip, intrigue, petty class rivalry, and conspicuous displays of cheap clothing . . . I liked it and I did not like it; I longed to be among them, yet when with them I looked at them as if I were a million miles away. I had been kept out of their world too long ever to be able to become a real part of it.

—*from* BLACK BOY, *by Richard Wright*

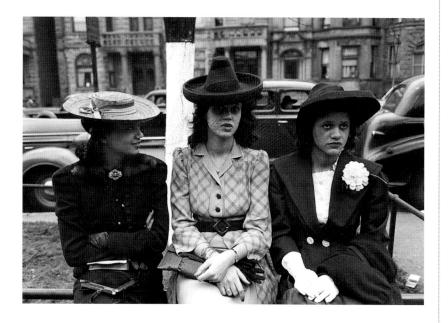

Waiting for a ride to church, Chicago, Illinois

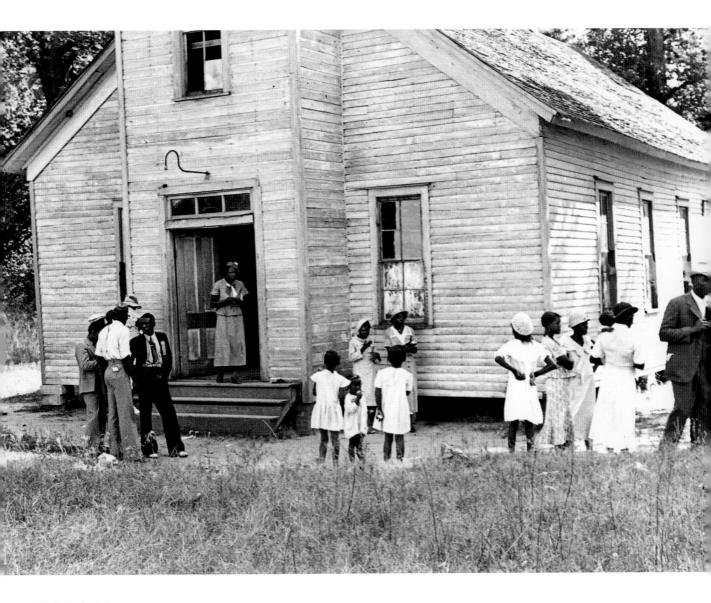

Little Rock, Arkansas

THIS ONE IS A LITTLE plumper than I am. Her eyes are brown. Her name is Ofglen, and that's about all I know about her. She walks demurely, head down, red-gloved hands clasped in front, with short little steps like a trained pig's, on its hind legs. During these walks she has never said anything that was not strictly orthodox, but then, neither have I. She may be a real believer, a Handmaid in more than name. I can't take the risk.

"The war is going well, I hear," she says.

"Praise be," I reply.

"We've been sent good weather."

"Which I receive with joy."

"They've defeated more of the rebels, since yesterday."

"Praise be," I say. I don't ask her how she knows. "What were they?"

"Baptists. They had a stronghold in the Blue Hills. They smoked them out."

"Praise be."

Sometimes I wish she would just shut up and let me walk in peace.

—*from* THE HANDMAID'S TALE,
by Margaret Atwood

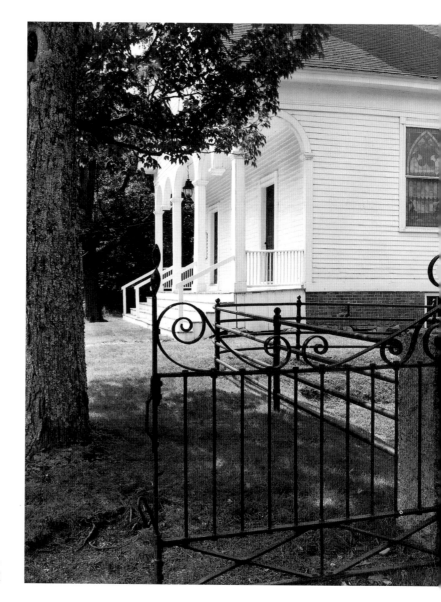

North Hampton, New Hampshire

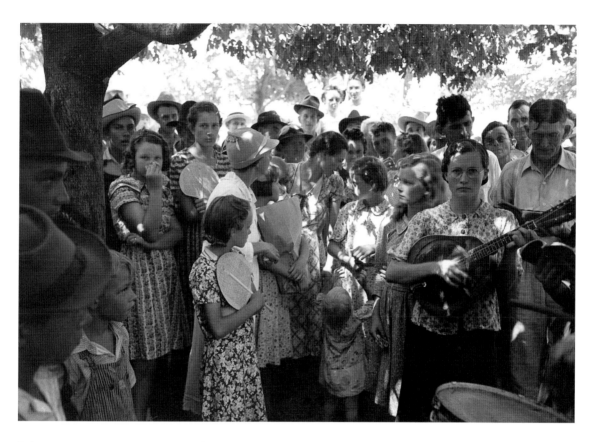

IT'S BECAUSE OF DISOBEDIENCE and sin, see, God made man first. Just like God told Adam what not to do and what to do, He told Eve first. But He made Adam first. And Adam could have stopped Eve if he wanted to, but when she went and the Devil deceived her and told her to eat that fruit, she went and told Adam. All Adam had to do was deny that fruit. But he didn't deny it. He went on and ate it. All he had to do was tell her, "No, I don't want it. You know what God said, and you shouldn't be eating it, and I'm not going to eat it either." We all could have been living forever. There would be no disease, no sin, no nothing. But he went on and took it. So I think it started right there. From that point, men started getting a little weaker. And a little weaker.

—*from a sermon by Pastor Carolyn King*

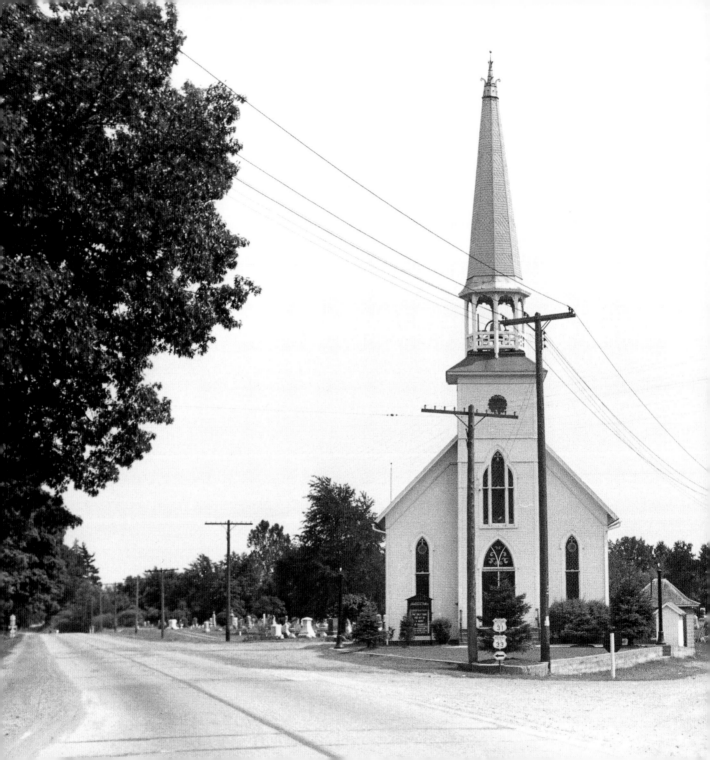

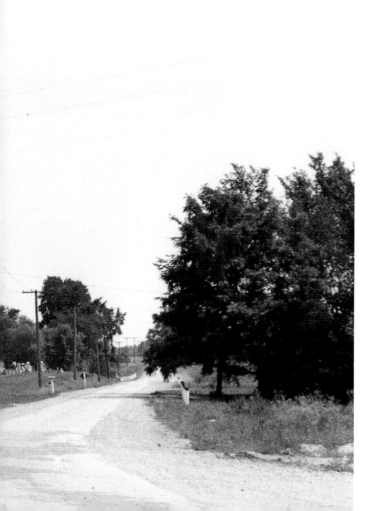

Now then, in the earth these people cannot stand much church—an hour and a quarter is the limit, and they draw the line at once a week. That is to say, Sunday. One day in seven; and even then they do not look forward to it with longing. And so—consider what their heaven provides for them: "church" that lasts forever, and a Sabbath that has no end! They quickly weary of this brief hebdomadal Sabbath here, yet they long for that eternal one; they dream of it, they talk about it, they *think* they think they are going to enjoy it—with all their simple hearts they think they think are going to be happy in it!

—*from* LETTERS FROM EARTH,
by Mark Twain

Sodus, Michigan

"*T*ell the *rest* of us how to be saved,
Preacher," one hypocrite pleaded.

—*from* A WALK ON THE WILD SIDE,
by Nelson Algren

St. Johnsbury, Vermont

*H*e was gret on texts, the doctor was. When he hed a p'int to prove, he'd jest go thro' the Bible, and drive all the texts ahead o'him like a flock o'sheep; and then, if there was a text that seemed agin him, why, he'd come out with his Greek and Hebrew, and kind o' chase it 'round a spell, jest as ye see a feller chase a contrary bell-wether, and make him jump the fence arter the rest. I tell you, there wa'n't no text in the Bible that could stand agin the doctor when his blood was up.

—*from "*THE MINISTER'S HOUSEKEEPER*,"
by Harriet Beecher Stowe*

*W*aiting, watching the street and the gate from the dark study window, Hightower hears the distant music when it first begins.

Hingham, Massachusetts

He does not know that he expects it, that on each Wednesday and Sunday night, sitting in the dark window, he waits for it to begin. He knows almost to the second when he should begin to hear it, without recourse to watch or clock. He uses neither, has needed neither for twentyfive years now.

—*from* LIGHT IN AUGUST, *by William Faulkner*

Stanwood, Washington

75

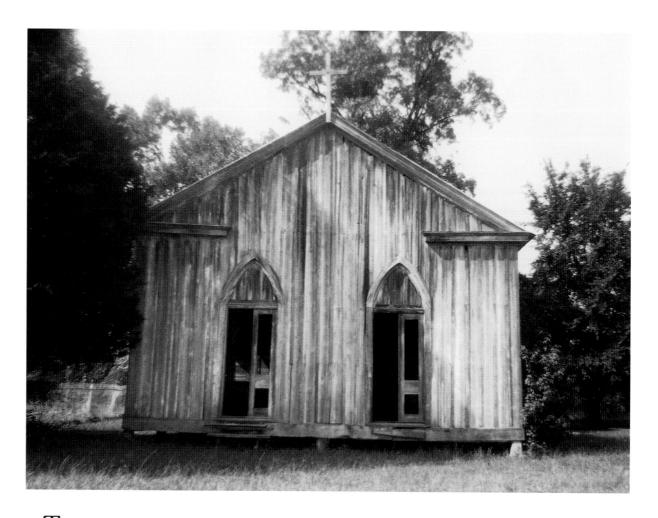

There warn't anybody at the church, except maybe a hog or two, for there warn't any lock on the door, and hogs like a puncheon floor in summertime because it's cool. If you notice, most folks don't go to church only when they've got to; but a hog is different.

—*from* HUCKLEBERRY FINN, *by Mark Twain*

ONLY C. W. POST WOULD have added a cantaloupe to the *Last Supper*. Perhaps unable to delete the wine, C. W. Post had settled for simply adding fruits and vegetables to balance the destructive influence of meat, to make art at least neutral. She knew that would be the way he would conceive of it. Two wrongs did not make a right but they balanced each other, just as the world itself stood in balance, barely holding on between heaven and hell, just as mankind hovered at the edge of sin and death thirsting for eternal life. A melon, a spot of grace at the corner of a painting, might save Leonardo and anyone through the millennia who looked at his work.

—*from* THE PROPHETEERS, *by Max Apple*

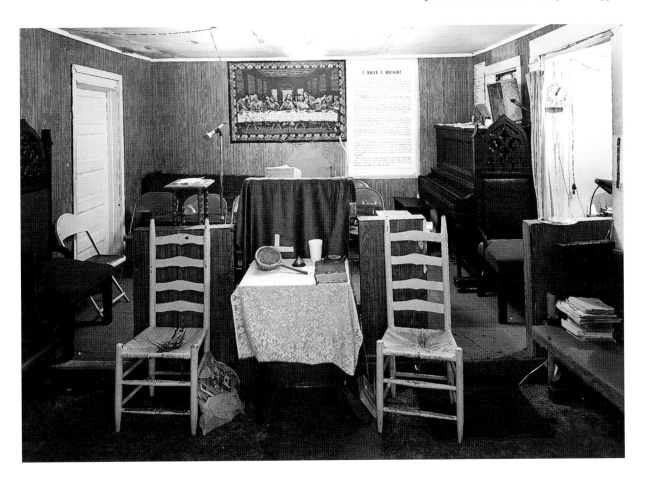

Little Ebenezer Baptist Church, Rosedale, Mississippi

Decatur County, Georgia

HE WANTED ALL of them to enter; he wanted to run through the streets and drag all sinners in to hear the Word of God. Yet, as they approached the doors, the fear held in check so many days and nights rose in him again, and he thought how he would stand tonight, so high, and all alone, to vindicate the testimony that had fallen from his lips, that God had called him to preach.

"Sister Deborah," he said, suddenly, as they stood before the doors, "you sit where I can see you?"

"I sure will do that, Reverend," she said. "You go on up there. Trust God."

Without another word he turned, leaving her in the door, and walked up the long aisle to the pulpit. They were all there already, big, comfortable, ordained men; they smiled and nodded as he mounted the pulpit steps; and one of them said, nodding toward the congregation, which was as spirited as any evangelist could wish: "Just getting these folks warmed up for you, boy. Want to see you make them *holler* tonight."

—*from* GO TELL IT ON THE MOUNTAIN, *by James Baldwin*

Webster County, Nebraska

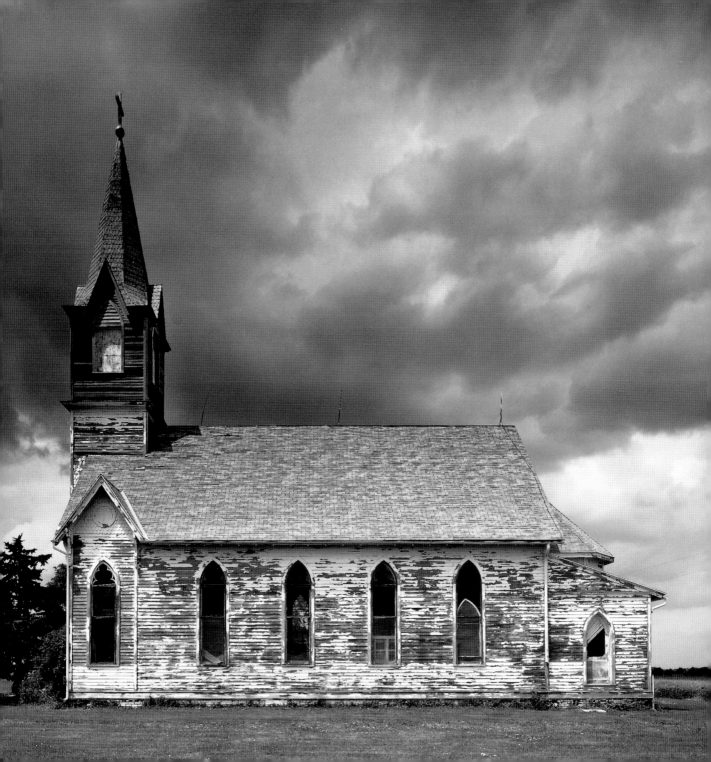

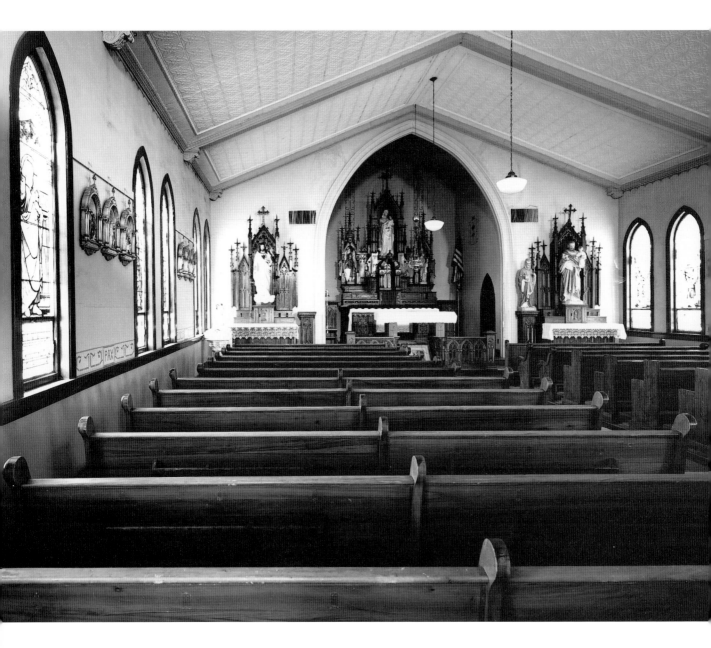

Wilson Church, Colfax County, Nebraska

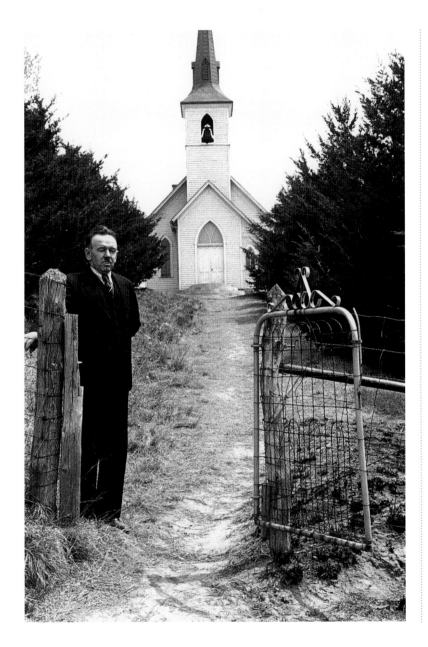

Lutheran church and pastor, Monona County, Iowa

*T*he church, in Chapel Hill, North Carolina, is Presbyterian. It is fairly conventional, though influenced, certainly, by the university community. Swain is happy here. Westside suits him. But it is clearly not the best place to hold the pastorate if you're the sort who's inclined to hear the actual voice of God. Up until recently, this would not have been a problem for Swain. But about eight weeks ago, the situation changed. At that time, Swain did indeed hear God.

—*from "THE PURE IN HEART,"*
by Peggy Payne

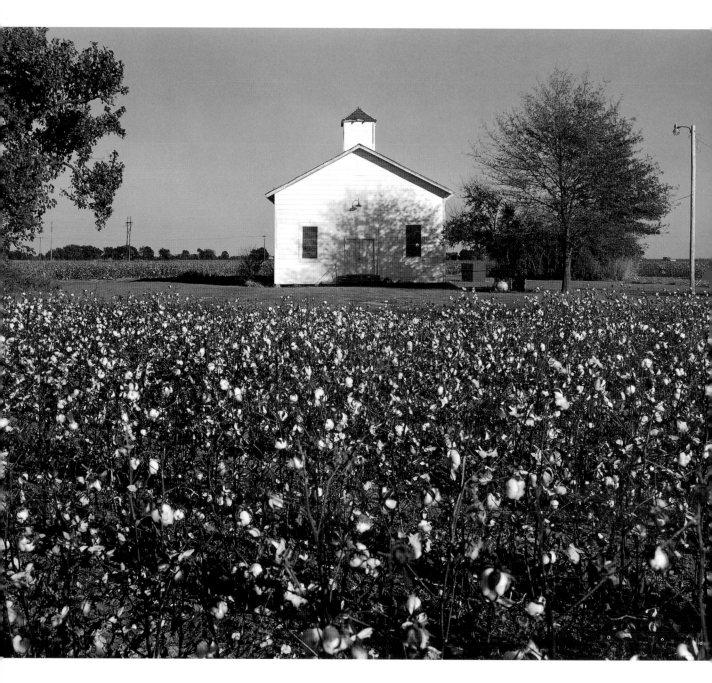

Pleasant Green Missionary Baptist Church, Rolling Fork, Mississippi

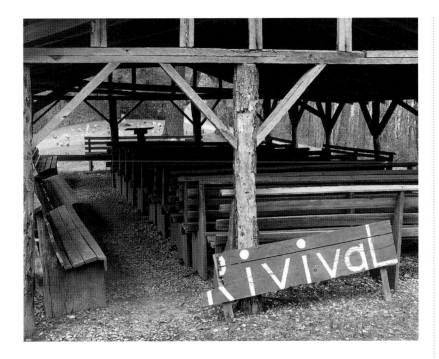

A wave of zeal and fiery enthusiasm swept over them. They longed for a Jerusalem to deliver.

—*from* O Pioneers!,
by Willa Cather

BENEFIELD'S SERMON WAS over. His doubleknit coat hung on the back of the pulpit chair. In spite of two fans directed on him, his short-sleeved shirt clung wetly to his skin. His broad face was flushed and his eyes seemed to send out charged blue rays. He had left the pulpit to come down near the congregation.

"Before I came out here," he said, "I looked up the word 'revival' in my son's new college dictionary. Just out of curiosity. What it said was 'to return to consciousness, to life.' Now . . . " He lowered his head, then raised it. "If you really want a new life, for yourselves and this old church, I want you to stand up and be counted tonight. I want you to come down here and give me your hand. Because if you don't want that, I'd just as well pack up my suitcase and head on back home."

—*from "*TONGUES OF FLAME,*" by Mary Ward Brown*

Priest at Pointe a la Hache,
Louisiana

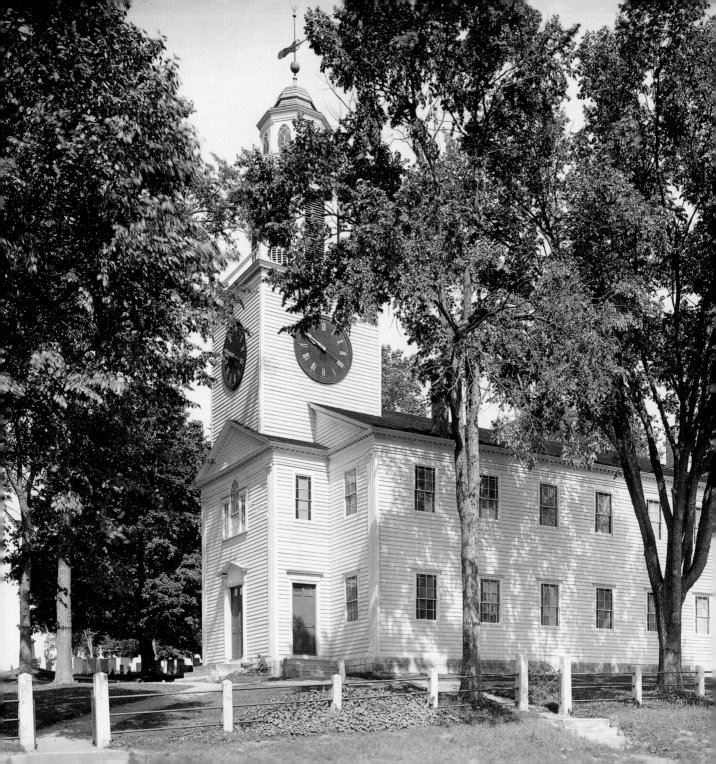

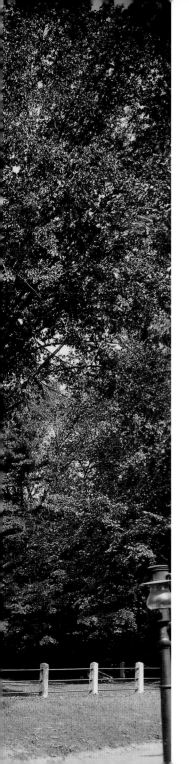

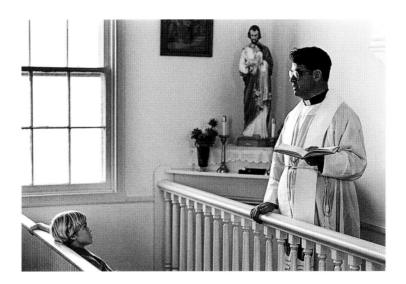

I don't remember Sunday school in the Congregational Church at all—although my mother claimed that this was always an occasion whereat I ate a lot, both in Sunday school and at various parish-house functions. I vaguely remember the cider and the cookies; but I remember emphatically—with a crisp, winter-day brightness—the white clapboard church, the black steeple clock, and the services that were always held on the second floor in an informal, well-lit, meetinghouse atmosphere. You could look out the tall windows at the branches of the towering trees.

—*from* A PRAYER FOR OWEN MEANY, *by John Irving*

Lenox, Massachusetts

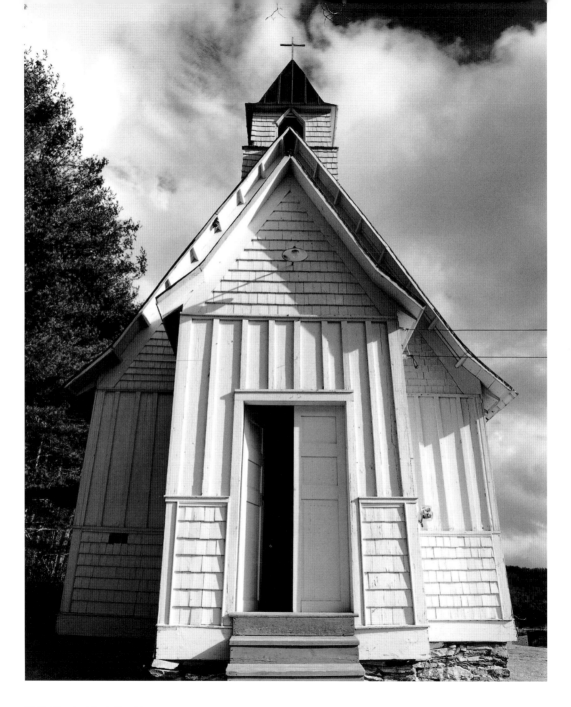

Valle Crucis, North Carolina

St. Andrews Episcopal Church, Chelan, Washington

carpenter, though there was no reason to include this defect in his act of contrition, he did not think . . .

—*from* ALL SOULS' RISING, *by Madison Smartt Bell*

"*D*omine, non sum dignus," Pére Bonne-chance intoned, kneeling before the altar of his church—no more, actually, than a bench of board which supported two planks nailed together for a cross. The cross was wrongly proportioned, closer to equilateral than it ought to have been, like a Maltese cross. Pére Bonne-chance was an extraordinarily poor

St. Peter's Chapel-at-Ease, Tacoma, Washington

*T*he ceiling was patterned with curious paneling that looked like row on row of tiny doors, just large enough to squeeze into, and through her particular door, above and slightly to the left of Grandmother McGovern's pew, Anna entered the tunnel.

—*from* A FAMILY'S AFFAIRS, *by Ellen Douglas*

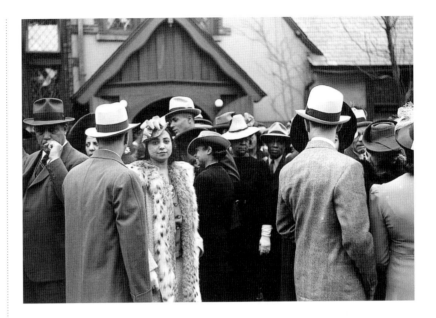

You could tell a little something by her eyes, with their devious candor (like a drunk's), but her troubles, whatever they were, didn't start with the bottle, and after a while the bottle wasn't what stopped them.

Glory be to the Father
she sang the Sunday before Labor Day. She wore her neckline low, her hem and heels and spirits as high as fashion and propriety would allow.

*and to the Son and to the
 Holy Ghost*
When she warbled in the sanctuary, her freckled bosom rippled in vibrato.

She left no fingerprints on the salver as she dropped in her tithe.

as it was in the beginning
She kept herself retouched, forever presenting the same bright portrait to the saints.

is now and ever shall be
Her cordial eyes, fixed in bravado, were shining

windows, bolted against bad weather.

world without end, amen
Behind them, fear, that restless housecat, paced.

amen.
She hated many things, but Sundays most of all.

—*from "INEXORABLE PROGRESS,"
by Mary Hood*

Ahead, where the forest abruptly stops, the
slanted sunlight falls very clear and bright.
A green lawn slopes downward to where another
creek flows, nestled among shaggy cedars.
In the lap of that lawn a white church blazes,
its sharp steeple rising above a broad oak.

—*from* DREAM BOY, *by Jim Grimsley*

Climax, Georgia

Estill, Mississippi

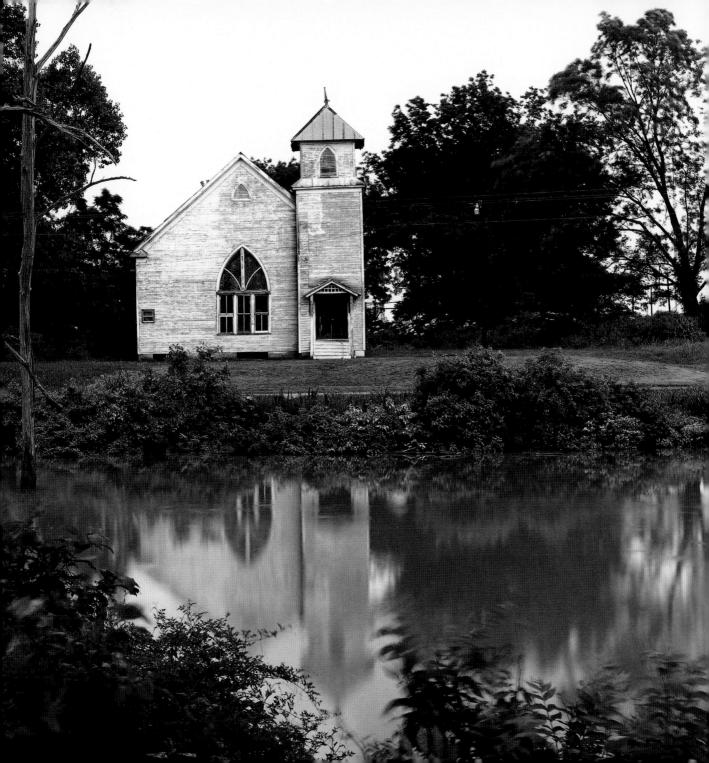

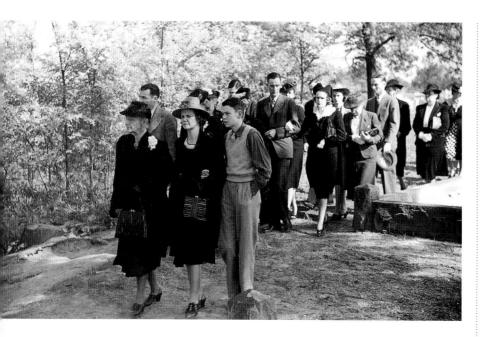

I was standing by the door in a pack of late arrivals, still thinking about Zoe, I admit it, when I first saw Dolores. The tiny church was crowded, but she had half a pew at the back to herself, so I slid in next to her. Immediately four or five people followed and sat on my other side, filling the rest of the pew. It wasn't too hard to see what the difficulty was—these people liked Dolores, she was one of them, and they felt as profoundly sorry for her as for themselves; but they also could not help blaming her and wanting to cast her out. They would have preferred that she simply disappear from town for a while, go and stay with her son in Plattsburgh or at least hide behind the door of her house with her husband up there on Bartlett Hill. They wanted her to stash her pain and guilt where they didn't have to look at it.

—*from* THE SWEET HEREAFTER,
by Russell Banks

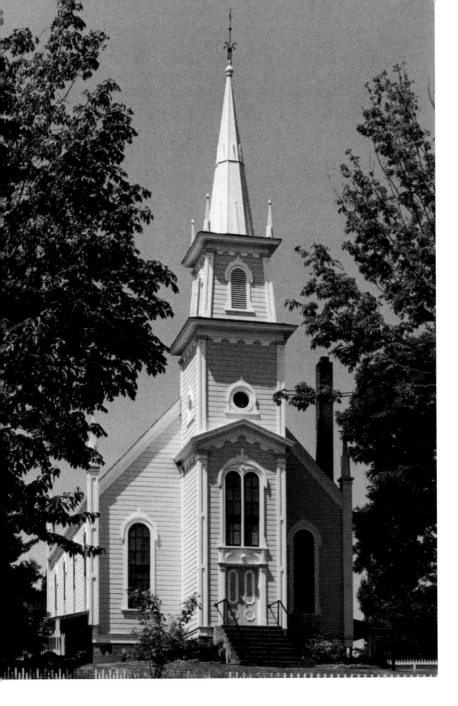

St. Paul's Episcopal Church, Port Gamble, Washington

THE PRESBYTERIAN CHURCH held itself somewhat aloof from the other churches of Winesburg. It was larger and more imposing and its minister was better paid. He even had a carriage of his own and on summer evenings sometimes drove about town with his wife. Through Main Street and up and down Buckeye Street he went, bowing gravely to the people, while his wife, afire with secret pride, looked at him out of the corners of her eyes and worried lest the horse become frightened and run away.

—from WINESBURG, OHIO,
by Sherwood Anderson

*H*e lay there on a bed of cold pebbles, the cool water washing, rippling over him; he wished he were a leaf, like the current-carried leaves riding past: leaf-boy, he would float lightly away, float and fade into a river, an ocean, the world's great flood. Holding his nose, he put his head underwater: he was six years old, and his penny-colored eyes were round with terror: Holy Ghost, the preacher said, pressing him down into baptism water; he screamed, and his mother, watching from a front pew, rushed forward, took him in her arms, held him, whispered softly: my darling, my darling. He lifted his face from the great stillness, and, as Idabel splashed a playful wave, seven years vanished in an instant.

"You look like a plucked chicken," said Idabel. "So skinny and white."

—*from* OTHER VOICES, OTHER ROOMS, *by Truman Capote*

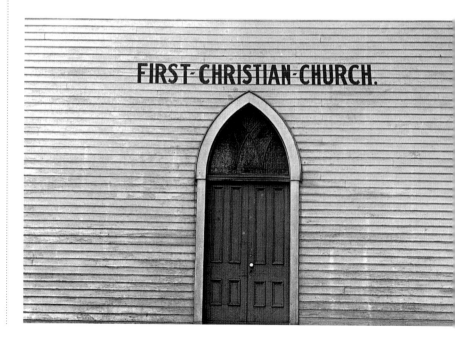

First Christian Church, central Ohio

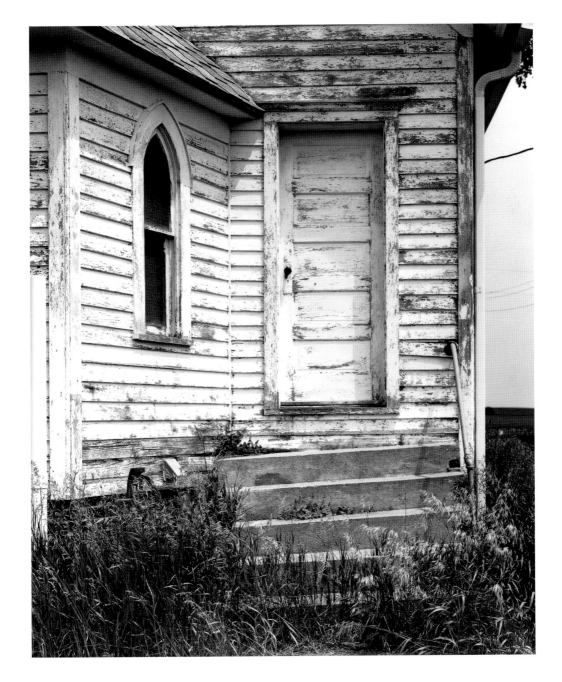

Madison County, Nebraska

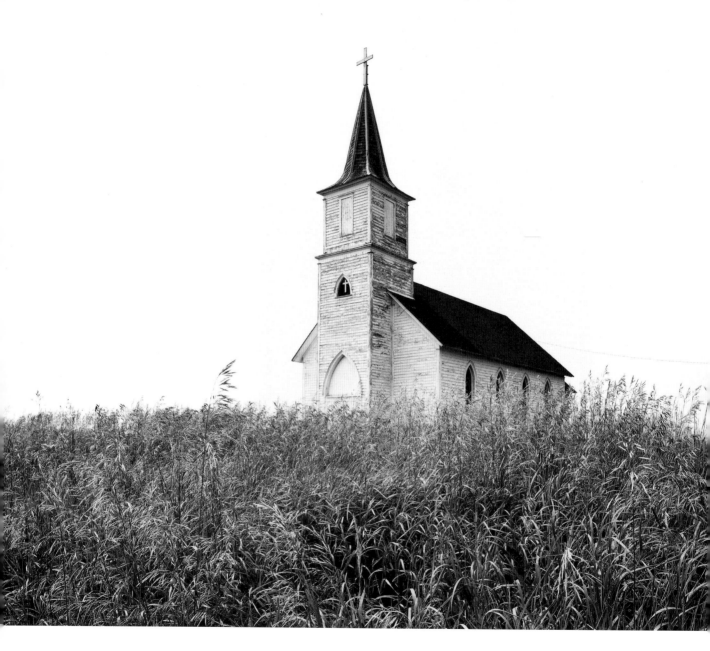

Seward County, Nebraska

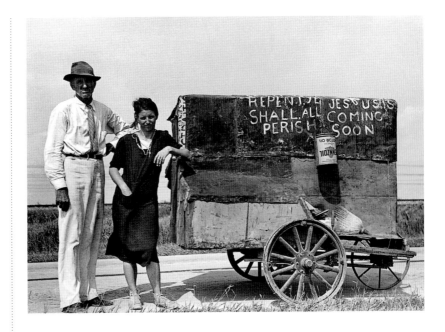

*H*e was against modern dancing, modern dress, swearing, gambling, cigarettes and sin. He preached that the long drought of 1930 was God's way of putting an end to such things. But as the drought went on and on and never a drop of rain he reversed himself and said it must be the pope's doing.

He was also said to be against fornication. But then it was said he was against corn whiskey too.

Saturday nights he pulled an ancient black frock coat over his patches; a coat with a pocket under the slit of the tail to hold the little brown bottle he called his "Kill-Devil." Getting stiff on the courthouse steps while denouncing the Roman Catholic clergy was a feat which regularly attracted scoffers and true believers alike, the believers as barefoot as the scoffers. For drunk as a dog or broke as a beggar, Fitz could spout religion like a hog in a bucket of slops.

Sometimes a girl would stand a moment among the men, pretending interest in The Word. But hunger has a scent more dry than love's and she would move along wishing she were in Dallas.

—*from* A WALK ON THE WILD SIDE, *by Nelson Algren*

EVERY SUNDAY MORNING, then, since John could remember, they had taken to the streets, the Grimes family on their way to church. Sinners along the avenue watched them—men still wearing their Saturday-night clothes, wrinkled and dusty now, muddy-eyed and muddy-faced; and women with harsh voices and tight, bright dresses, cigarettes between their fingers or held tightly in the corners of their mouths. They talked, and laughed, and fought together, and the women fought like the men. John and Roy, passing these men and women, looked at one another briefly, John embarrassed and Roy amused. Roy would be like them when he grew up, if the Lord did not change his heart.

—from GO TELL IT ON THE MOUNTAIN, *by James Baldwin*

*H*e looked at them, almost glaring. His eyes moved over the small crowd, which waited, polite, and not uninterested, to hear what he would say next. "I love this sermon," he thought, as he adjusted his glasses.

—from THE VILLAGE, *by David Mamet*

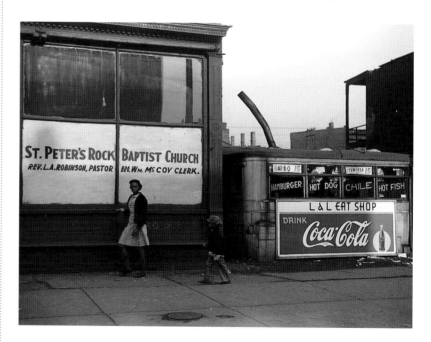

Chicago, Illinois

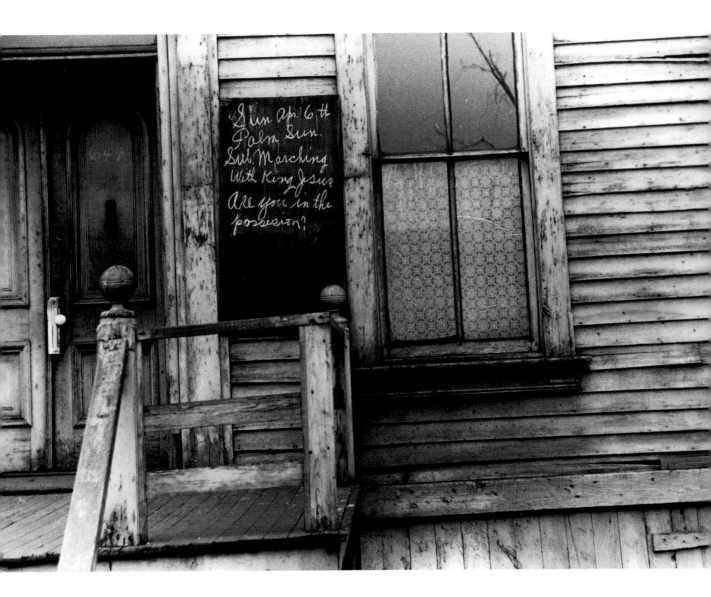

Chicago, Illinois

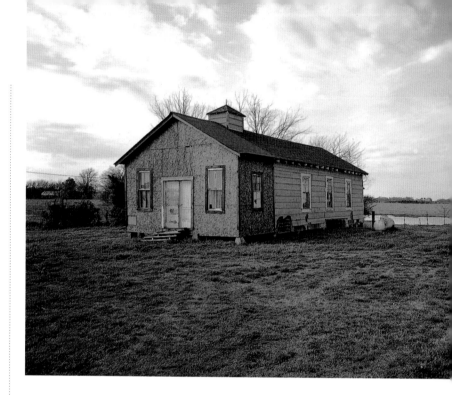

If they jeered when he faced them, he would be ruined, he would still lose the Yorkville pastorate and the Napap. Thus he fretted in the quarter-hour before morning service, pacing his study and noting through the window—for once, without satisfaction—that hundreds on hundreds were trying to get into the crammed auditorium.

His study was so quiet. How he missed Hettie's presence!

He knelt. He did not so much pray as yearn inarticulately. But this came out clearly: "I've learned my lesson. I'll never look at a girl again. I'm going to be the head of all the moral agencies in the country—nothing can stop me, now I've got the Napap!—but I'm going to be all the things I want other folks to be! Never again!"

He stood at his study door, watching the robed choir filing out to the auditorium chanting. He realized how he had come to love the details of his church; how, if his people betrayed him now, he would miss it: the choir, the pulpit, the singing, the adoring faces.

It had come. He could not put it off. He had to face them.

Feebly the Reverend Dr. Gantry wavered through the door to the auditorium and exposed himself to twenty-five hundred question marks.

They rose and cheered—cheered—cheered. Theirs were the shining faces of friends.

Without planning it, Elmer knelt on the platform, holding his hands out to them, sobbing, and with him they all knelt and sobbed and prayed, while outside the locked glass door of the church, seeing the mob kneel within, hundreds knelt on the steps of the church, on the sidewalk, all down the block.

"Oh, my friends!" cried Elmer, "do you believe in my innocence, in the fiendishness of my accusers? Reassure me with a hallelujah!"

—*from* Elmer Gantry, *by Sinclair Lewis*

Beulah, Mississippi

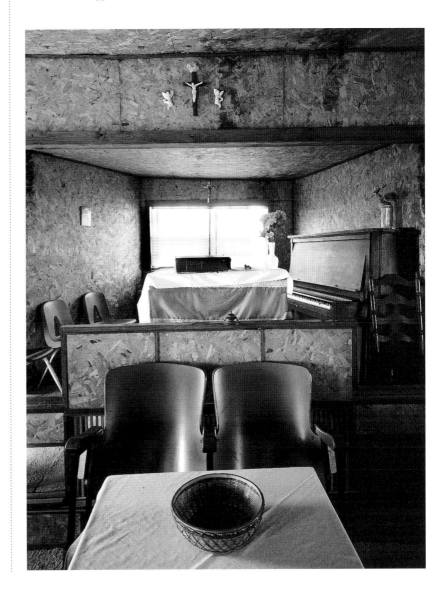

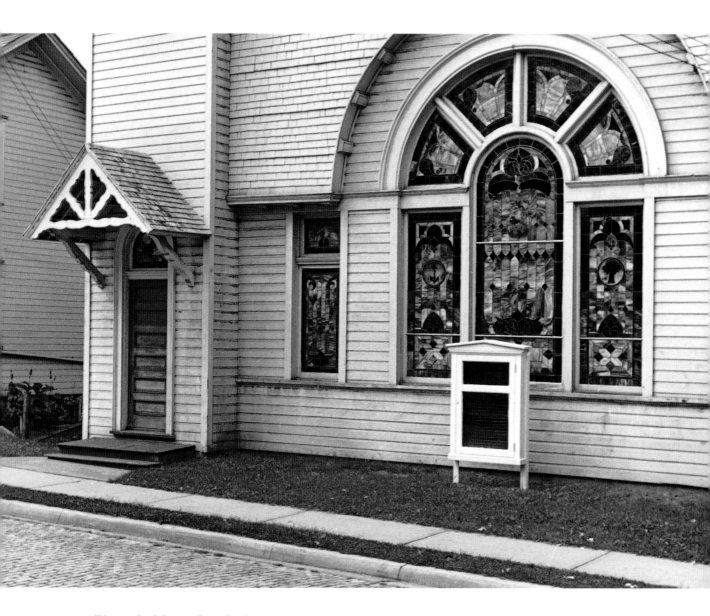

Westmoreland County, Pennsylvania

*I*f he was to say, "I believe in God the Father, God the Son, and God the Holy Ghost," his dad would say, "A person sure wouldn't know it to look at you." Or he would say, "Don't talk with your mouth full," or "It's about time," or maybe he would convert to Unitarianism on the spot ("The Trinity? Don't be ridiculous!").

—*from* LAKE WOBEGON DAYS, *by Garrison Keillor*

ON THE WINDOW, made of little leaded panes, was a design showing the Christ laying his hand upon the head of a child. One Sunday morning in the summer as he sat by his desk in the room with a large Bible opened before him, and the sheets of his sermon scattered about, the minister was shocked to see, in the upper room of the house next door, a woman lying in her bed and smoking a cigarette while she read a book. Curtis Hartman went on tiptoe to the window and closed it softly. He was horror stricken at the thought of a woman smoking and trembled also to think that his eyes, just raised from the pages of the book of God, had looked upon the bare shoulders and white throat of a woman.

—*from* WINESBURG, OHIO, *by Sherwood Anderson*

Jefferson City, Missouri

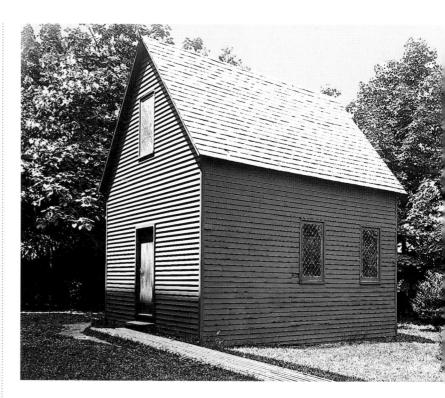

*A*mazing grace!

how sweet the sound,

that saved a wretch like me!

I once was lost, but now

 I'm found,

Was blind but now I see.

—*from "AMAZING GRACE,"*
by John Newton

Baptist deacon, Jackson, Mississippi

EACH FELT THE IMPULSE in himself, and in the same breath, caught it from his neighbor. Within the church, it had hardly been kept down; beneath the sky, it pealed upward to the zenith. There were human beings enough, and enough of highly wrought and symphonious feeling, to produce that more impressive sound than the organ tones of the blast, or the thunder, or the roar of the sea; even that mighty swell of many voices, blended into one great voice by the universal impulse which makes likewise one vast heart out of the many. Never, from the soil of New England, had gone up such a shout! Never, on New England soil, had stood the man so honored by his mortal brethren as the preacher.

—*from* THE SCARLET LETTER, *by Nathaniel Hawthorne*

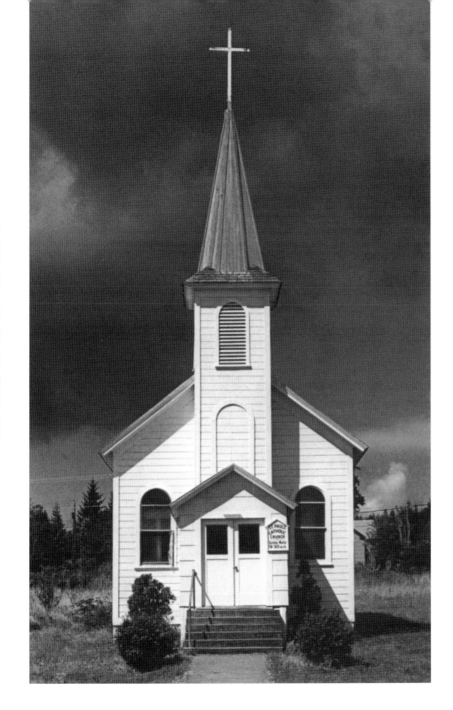

"Where were you going that day in Kentucky, walking through the grass?"

"I don't remember now. I was just walking diagonally across a big field. My sun-bonnet obstructed the view. I could see only the stretch of green before me, and I felt as if I must walk on forever, without coming to the end of it. I don't remember whether I was frightened or pleased. I must have been entertained.

"Likely as not it was Sunday," she laughed; "and I was running away from prayers, from the Presbyterian service, read in a spirit of gloom by my father that chills me yet to think of."

"And have you been running away from prayers ever since, *ma chère?*" asked Madame Ratignolle, amused.

—*from* THE AWAKENING,
by Kate Chopin

Swinomish Indian Reservation, Washington

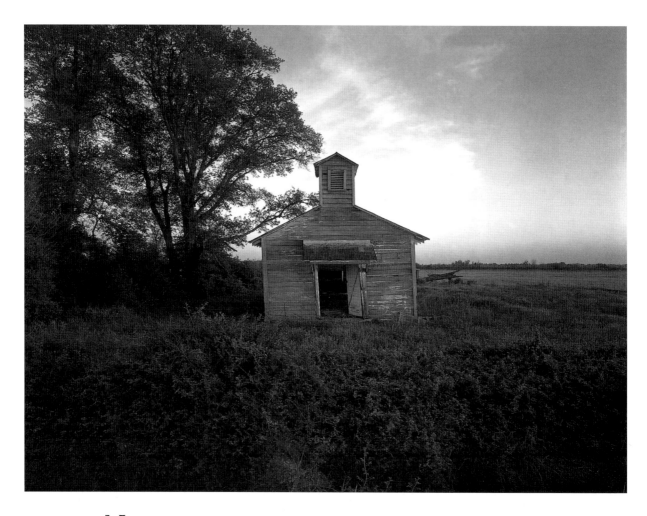

Now we are gathered in a little church in the woods . . . and we are here
to say our last goodbyes to Dwight. . . . The church will not hold all the people
who have come here. The church has no paint on the outside.

—*from* ON FIRE, *by Larry Brown*

HANNA TROUT STOOD UP with the others and walked to the front of the chapel. She carried her purse under her arm. The preacher took one of her hands, the older man took the other. Her purse fell to the floor. The littlest child swayed between the two younger men, her eyes fastened on Hanna's white skin.

Hanna watched the child and then looked into the casket.

There was another child inside, the one she had taken to Cornell Clinic for rabies treatment. They had laid her head on a pink satin pillow.

The preacher closed his eyes and spoke. "Jesus, thank you for sending us this little girl," he said. "We return her to You now for safekeeping and pray for You to forgive us that we didn't take better care of her here."

They all said "A-men," even the children.

The preacher closed the lid to the coffin, and he and the three men carried it across the street to a mound of freshly dug dirt. They set the box down, took off their coats, and then lowered it into the ground.

—*from* PARIS TROUT, *by Pete Dexter*

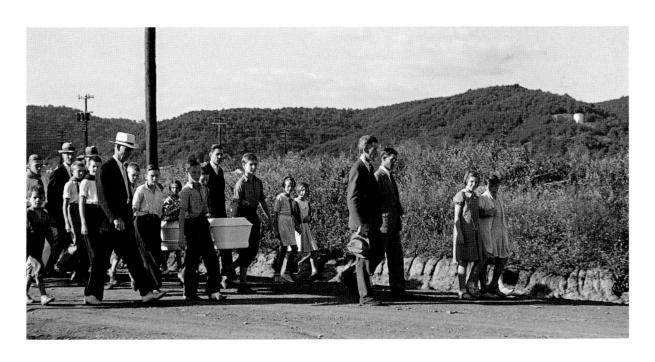

Funeral of a boy, Red House Farms, West Virginia

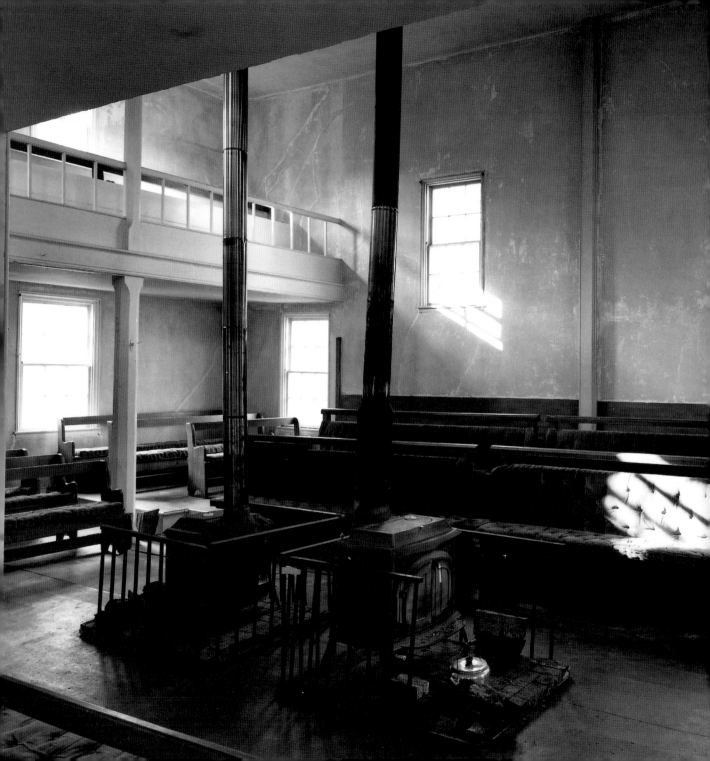

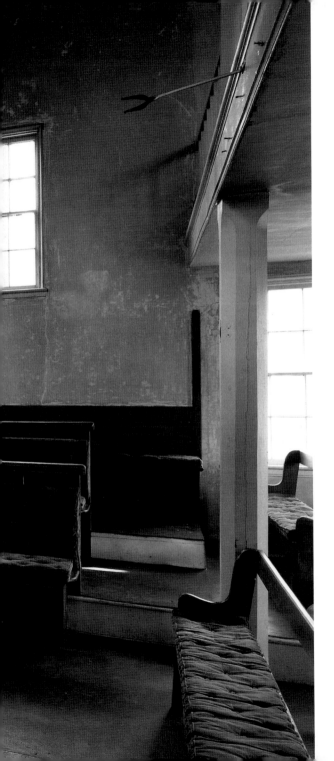

No lights were lit, but his eyes
adjusted quickly to the gloom.
He made out rows of cushioned pews
and a carved wooden pulpit up front,
with another stained-glass window
high in the wall behind it. This one
showed Jesus in a white robe, barefoot,
holding His hands palm forward at
His sides and gazing down at Ian
kindly. Ian slid into a pew and rested
his elbows on the pew ahead of him.
He looked up into Jesus' face. He said,
*Would it be possible for me to have some
kind of sign?*

*Nothing fancy. Just something
more definite than Reverend Emmett
offering a suggestion.*

—*from* Saint Maybe, *by Anne Tyler*

Amawalk Friends Meeting, Yorktown Heights, New York

THEY WISH TO SPEAK of their wishes
and determination in that respect
themselves, and to be heard by the
representatives of the United States;
they wish them to be convinced, that,
to know their feelings and interests,
is to know that they ardently desire
to remain in peace and quietude upon
their ancient territory, and to enjoy
the comforts and advantages of
civilization; that the great mass of
our citizens are opposed to removal,
(as has been plainly demonstrated by
the offers and inducements lately held
out to them) and that it is not the fear
of chiefs that has forced upon them
their determination to remain; but
that it has been produced by causes
no less than convincing evidence,
that their only and best hopes of
preservation and advancement in
moral and civil improvement is to
remain where their Great Father
alone placed them.

—*from* THE CHEROKEE
MEMORIALS OF 1829

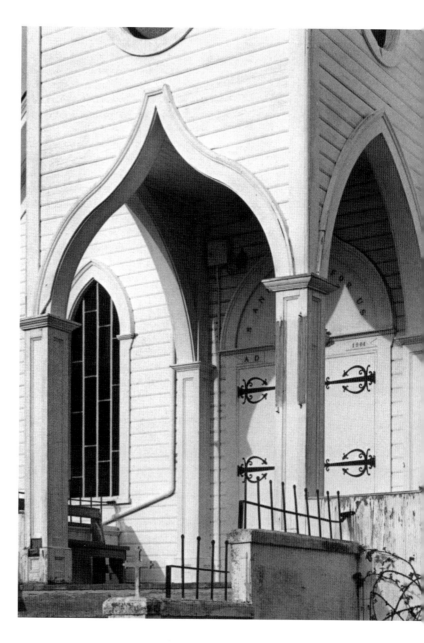

St. Anne's Catholic Church, Tulalip Indian Reservation, Washington

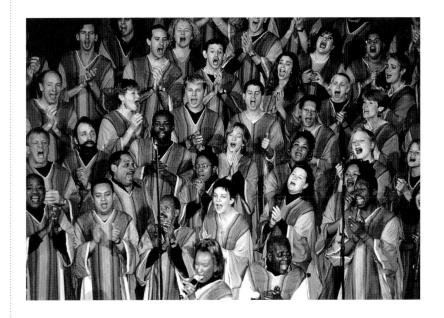

I pray for the soul of my grandfather. I do not bear him any anger. Sometimes I got to Mass during the week. Versailles has a Catholic church just for the Vietnamese and the Mass is celebrated in our language. I sit near the back and I look at the section where all the old women go. They take the Eucharist every day of their lives and they sit together wearing their traditional dresses and with their hair in scarves rolled up on their heads and I wonder if that is where I will finally end up, in the old women's section at Mass each day. No one in my church will likely live as long as a parrot. But our savior lived only thirty-three years, so maybe it's not important. There were women around Jesus when He died, the two Marys. They couldn't do anything for Him. But neither could the men, who had all run away.

—*from* A GOOD SCENT FROM A STRANGE MOUNTAIN, *by Robert Olen Butler*

Pulpit, Decatur County, Georgia

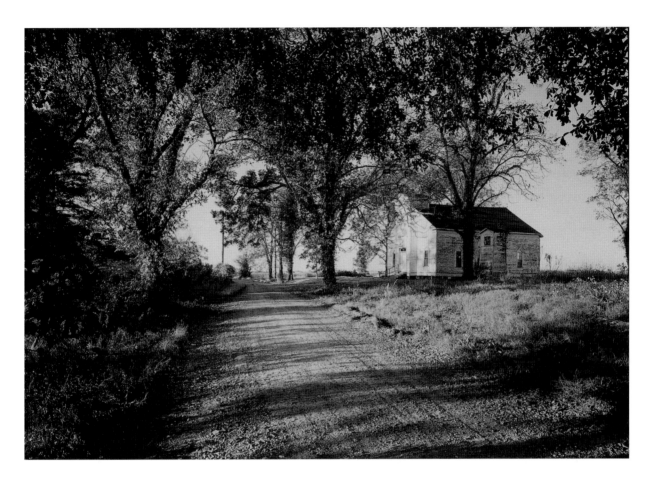

*T*he scientist's religious feeling takes the form of rapturous amazement at the harmony
of natural law, which reveals an intelligence of such superiority that, in comparison
with it, the highest intelligence of human beings is an utterly insignificant reflection.
This feeling is the guiding principle of his life and work.

—*Albert Einstein*

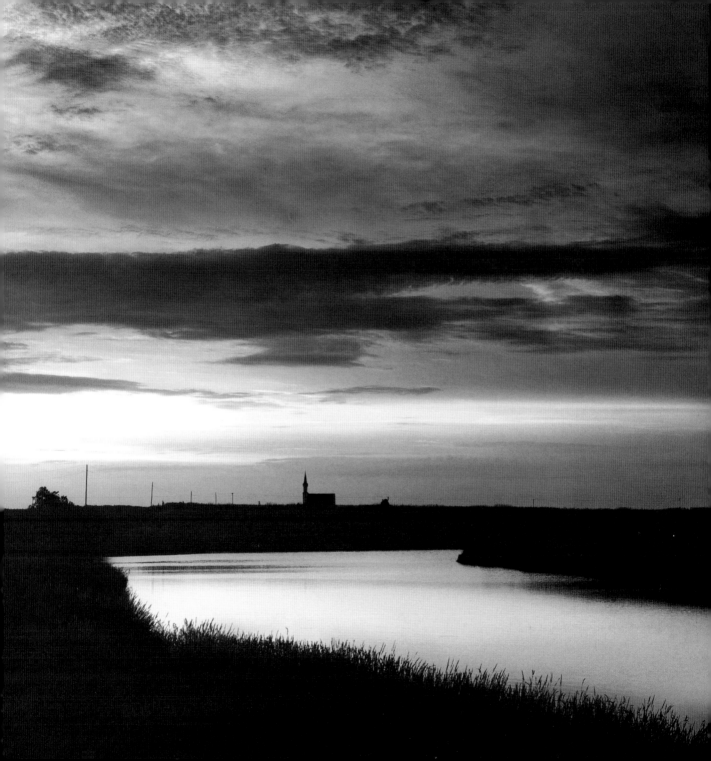

*B*ut our rulers can have authority
over such natural rights only as we have
submitted to them. The rights
of conscience we never submitted,
we could not submit.
We are answerable for them
to our God.

—*from* NOTES ON THE STATE OF VIRGINIA,
by Thomas Jefferson

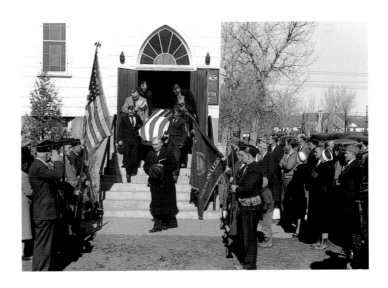

Funeral of a veteran, Glasgow, Montana

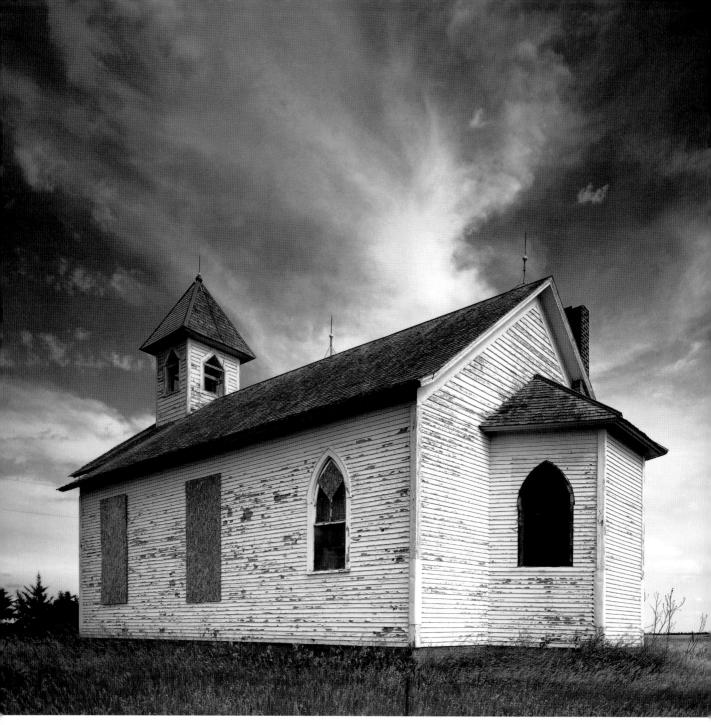

INDEX

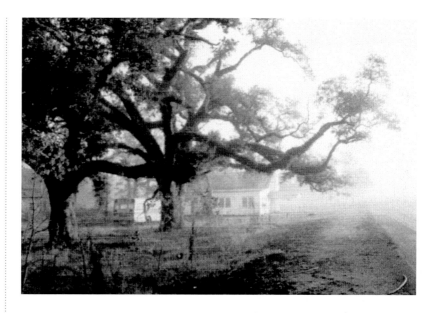

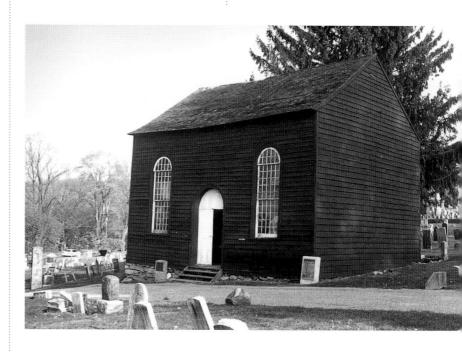

Van Cortlandville, New York

CREDITS

TEXT

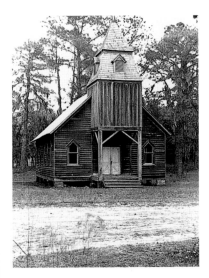

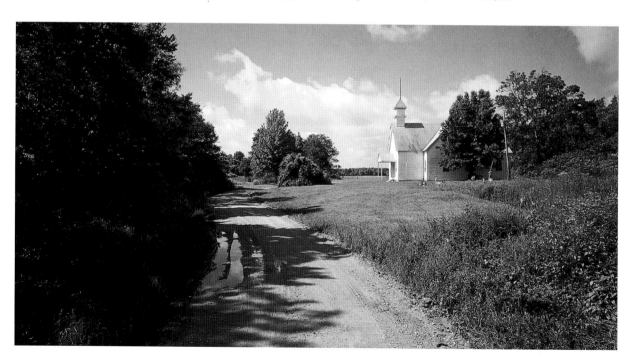

Jonestown, Mississippi

PHOTOGRAPHS

i © Micah Marty. From *Our Hope for Years to Come.* Reprinted by permission.

ii. © Micah Marty. From *Our Hope for Years to Come.* Reprinted by permission.

iii ©William Christenberry

iv-v © Steve Procko

vi. © Rob Amberg

8 Marion Post Wolcott

9 Arthur Rothstein

10 Summerdale Community Church

11 The North Carolina Historical Collection

12 (left) The North Dakota Institute for Regional Studies

12 and 13 (center) Russell Lee

13 (right) The North Dakota Institute for Regional Studies

14 © Tom Rankin

15 Eudora Welty Collection—Mississippi Department of Archives and History

16 (top) © Tom Rankin

16 (bottom) Marion Post Wolcott

17 © Tom Rankin

18 © Rob Amberg

20 © Ryan Jackson

21 (top) Ben Shahn

21 (bottom) Marion Post Wolcott

22 Arizona Department of Library, Archives and Public Records, 97-1629

23 The North Dakota Institute for Regional Studies

24 © Arthur Mazmanian

25 (top) © Tom Liden

25 (bottom) © Charles Gillespie

26 © Tom Rankin

27 Marion Post Wolcott

28 © Charles Henkels

29 Jana Birchum/Impact Visuals

30 © Arnold Pearson

31 The North Carolina Historical Collection

32 © Paul Kwilecki

33 © Paul Kwilecki

34 Summerdale Community Church

35 Ben Shahn

36 Detroit Publishing Company Photograph Collection

37 © Paul Kwilecki

38 © Arnold Pearson

39 (top) © Micah Marty. From *Our Hope for Years to Come.* Reprinted by permission.

39 (bottom) Ben Shahn

40 ©Southern Living, Inc. Art Meripol, photographer

41 (left) © Neal Chaves

41 (right) © Debbie Fleming Caffery

42 Marion Post Wolcott

43 © Paul Kwilecki

44 Arizona Department of Library, Archives and Public Records, 97-8668

45 (left) © Arnold Pearson

45 (right) © Abraham Menashe

46 © Micah Marty

47 Russell Lee

48 Walker Evans

49 (top) © Abraham Menashe

49 (bottom) © Abraham Menashe

50 © Tom Rankin

51 Ben Shahn

52 © Arnold Pearson

53 Jana Birchum/Impact Visuals

54 Eudora Welty Collection—Mississippi Department of Archives and History

55 Russell Lee

56 (left) © John Dolan

57 The Murrell Collection

58 © Tom Rankin

59 Eudora Welty Collection—Mississippi Department of Archives and History

60 © Renee Ingram, The African American Heritage Preservation Foundation

61 Library of Congress Collections

62 Library of Congress Collections

63 Library of Congress Collections

64 New York Landmarks Conservancy

65 Library of Congress Collections

66 Michigan Historical Center

67 (top) © Arnold Pearson

67 (bottom) © Micah Marty. From *Our Hope for Years to Come.* Reprinted by permission.

68 Russell Lee

69 Ben Shahn

70 ©Neal Chaves

71 Russell Lee

72 John Vachon

74 © Tom Way

75 (left) © Micah Marty. From *Our Hope for Years to Come.* Reprinted by permission.

75 (center) © Arthur Mazmanian

75 (right) © Arnold Pearson

76 © William Christenberry

77 © Tom Rankin

78 © Paul Kwilecki

79 © Micah Marty

80 © Micah Marty

81 John Vachon

82 © Tom Rankin

83 (top) © Steve Procko

83 (bottom) Ben Shahn

84 Detroit Publishing Company Photograph Collection

85 Bill Burke/Impact Visuals

86 © Steve Procko

87 (left) © Arnold Pearson

87 (center) © Arnold Pearson

87 (right) © Charles Gillespie

88 Arthur Rothstein

89 Edwin Rosskam

90 © Paul Kwilecki

91 © Tom Rankin

92 Jack Delano

93 © Arnold Pearson

94 (left) © Debbie Fleming Caffery

94 (right) Ben Shahn

95 © Micah Marty. From *Our Hope for Years to Come.* Reprinted by permission.

96 © Micah Marty. From *Our Hope for Years to Come.* Reprinted by permission.

97 Russell Lee

98 (left) Russell Lee

98 (right) Edwin Rosskam

99 Edwin Rosskam

100 © Tom Rankin

101 © Tom Rankin

102 Ben Shahn

103 (left) © Arnold Pearson

103 (right) John Vachon

104 (left) Eudora Welty Collection—Mississippi Department of Archives and History

104 (right) Detroit Publishing Company Photograph Collection

105 © Arnold Pearson

106 © Tom Rankin

107 Elmer Johnson

108 © Charles Henkels

110 © Arnold Pearson

111 Alain McLaughlin/Impact Visuals

112 © Paul Kwilecki

113 © Tom Rankin

114 © Micah Marty. From *Our Hope for Years to Come.* Reprinted by permission.

115 John Vachon

116 © Micah Marty. From *Our Hope for Years to Come.* Reprinted by permission.

117 © Debbie Fleming Caffery

118 New York Landmarks Conservancy

119 Walker Evans

120 © Tom Rankin

122 Eudora Welty Collection—Mississippi Department of Archives and History

Endpapers: © Tom Rankin

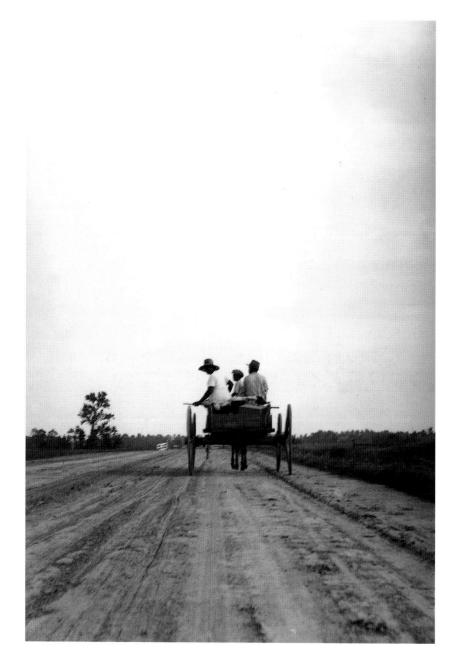

Home from church, Yalobusha County, Mississippi

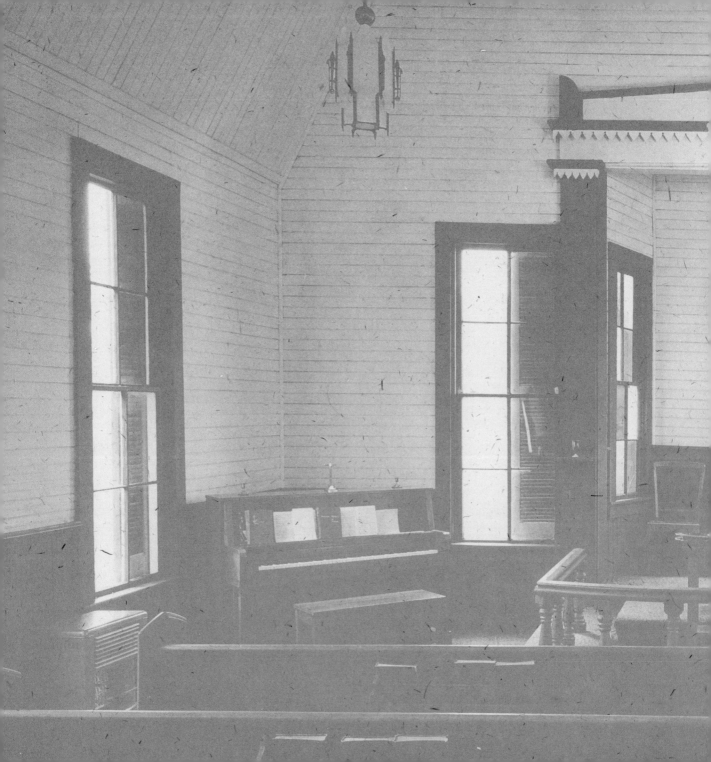